DIGITAL QUICK GUIDE™

DIGITAL CAMERA
TRICKS AND SPECIAL EFFECTS 101

To Ron . . . for everything.

Acknowledgments
Thanks to Nicholas Brandjes, Mr. Columbo, Ethan Maines, Kate Neaverth, Liam Neaverth, and Pokey for serving as models. Thanks, also, to Ron Eggers, Patrick Rice, and Mark Beck for contributing images.

Published by:
Amherst Media, Inc.
P.O. Box 586
Buffalo, N.Y. 14226
Fax: 716-874-4508
www.AmherstMedia.com

Publisher: Craig Alesse
Assistant Editor: Barbara A. Lynch-Johnt
Editorial Assistance: Carey Anne Maines

ISBN:1-58428-176-6
Library of Congress Card Catalog Number: 2005926591

Printed in Korea.
10 9 8 7 6 5 4 3 2 1

TABLE OF CONTENTS

INTRODUCTION

With digital photography, your images are instantaneous and, unlike with film, you can shoot as much as you want without incurring additional costs. As a result, you can easily experiment with unusual techniques to produce images that are far from average.

Additionally, image-editing software has made it possible to quickly transform your digital photos with fantastic special effects. In this book, you'll explore both modes of producing interesting—even completely surprising—photographic effects.

So, get out your digital camera, and let's get started—you'll be amazed at how quickly you can start capturing amazing images!

1. GETTING STARTED

For most photographers, digital imaging has made life easier, but for those of us interested in creating unusual, creative, or surprising special-effects images, digital has made life *a whole lot* easier.

Today, it's possible for even absolute beginners to produce effects that, with film photography, would have required the efforts of a master darkroom technician. What's even more amazing is the fact that the effects you can create using today's digital-imaging technology usually look better and can be accomplished in a fraction of the time. Additionally, we now have the ability to produce effects that were simply impossible without digital.

All in all, it's a great time to get interested in photography, and a great time to start learning how to create unique effects with your digital camera.

■ WHAT YOU'LL NEED

A Camera. To use the techniques in this book, you'll need a camera. It's really best to use a digital camera (see lesson 3 for tips on selecting one), but you can also accomplish some of the same effects using a film camera and scanning your images to import into your digital image-editing software.

Software. In a way, digital photography has become a lot like motion-picture making. Just as computer-generated effects and live-action footage are combined to create the special effects we see in today's movies, a combined approach is often the best and easiest way to create special effects in digital photography.

All in all, it's a great time to get interested in photography.

The examples in this book will use Adobe Photoshop Elements—one of the most popular and powerful image-editing programs currently on the market for nonprofessional photographers. If you decide you want to use Adobe Photoshop Elements and are totally new to the software, I recommend that you spend a little time familiarizing yourself with it before trying the techniques in this book. Of course, you can use other products to achieve great effects, too—you'll just find that the tools and menus are a bit different.

Some Willing Subjects/Assistants. It's lots of fun to shoot special-effects images of people, so if you have some hams/goofballs/comedians in your family or social circle, this is the time to get them in front of the camera. Kids are often very willing subjects and helpers—especially if you let them

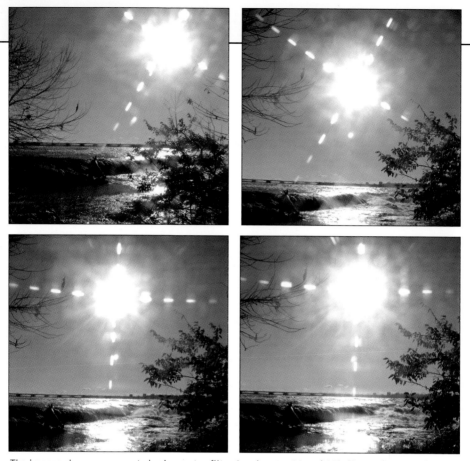

The images above were created using a star filter (see lessons 22 and 23). To get the sun at just the right height over the scene (and on a day with a clear sky) required some planning. Taking multiple shots and checking them on the LCD screen ensured the desired results were achieved.

check out the shots on the LCD screen as you shoot them and make suggestions for the next shot.

While you can do lots of special-effects photography by yourself, some shots are made quite a lot easier by having an extra pair of hands around to hold a prop or lighting device in place.

A Little Planning and Patience. Taking special-effects images usually requires some planning—you may need props, to work in a special location, to shoot a sequence of trial images, etc. Take your time and don't get frustrated if you have to try it a few times before you get the shot. Just check the images on your digital camera's LCD screen and keep refining the shot until you get it just right. Remember, taking a few extra frames doesn't cost you a cent with digital (and it's a lot easier than having to set up the shot again).

2. THE BASICS: RESOLUTION

Before you take a single shot, you should be sure to check your camera's resolution setting to ensure that you'll have all the image data (pixels) you need to carry out your plans for the image. The resolution of an image, to a great degree, determines the apparent quality of the image.

Resolution is such a big issue in digital imaging that when digital cameras are advertised, one of the first specifications listed for each model is the size of the file it is capable of creating. This is usually listed in megapixels. The larger the number, the more possibilities you'll have for your images—you can make bigger prints or crop the image more dramatically to improve the overall composition.

■ DON'T JUST GUESS

If you're not sure what resolution you need to create the product you have in mind, do some research *before* you create your file. There's no point in wasting your time creating an image that turns out to be unusable.

■ SO . . . WHICH RESOLUTION IS RIGHT?

The precise number of pixels you need will be determined by how you will use the image. If you want to use an image on your web page, you'll select a relatively low resolution—probably 72dpi. This is all that is needed to create an acceptably sharp image on a monitor.

IT'S *HOW* BIG?

There are two things to keep in mind when creating a digital image. First, ask yourself what the final dimensions of the image need to be. Do you want to make a billboard or a postage stamp? Next, determine what the final resolution of the image needs to be—72dpi? 300dpi? 1000dpi? Once you know the answers to these questions, you'll be ready to create an image (or determine if an existing image will suit your needs). All you need to do is multiply the resolution by the dimensions of the image. Here's how:

Imagine you're making a photo to put in a newsletter. The image needs to be 2" tall and 3" wide on the page, and your printer has told you that the resolution should be 300dpi. To make a file the right size, multiply 2" x 300dpi (for the height) and 3" x 300dpi (for the width). This tells you that you need an image that is 600 pixels tall and 900 pixels wide (600x900).

Later, one of the people in the photo asks if she can have a copy of this file to make an 8"x10" photo-quality print on her inkjet printer. She needs a final resolution of 700dpi. Will the same file work? Nope—your friend will need a much larger image file, one that is 5600 pixels wide (8" x 700dpi) and 7000 pixels tall (10" x 700dpi).

The resolution your image needs to be depends on how you want to use it. The image on the left is at 300dpi, perfect for printing in a book. The image on the right is at 72dpi. This would look just fine on a web site, but its resolution is too low to look good in print.

If you want to generate a photo-quality print on your inkjet printer, you may want to create a file as large as 700dpi. Check the manual that came with your printer to determine the resolutions recommended.

If you'll be having someone else (like a photo lab) print your image, ask them what they recommend. For more on this, see lesson 41.

If you'll be using your image in multiple applications (say you want to make a print but also plan to e-mail the photo to someone), create your image at the largest size you'll need. Make any needed enhancements to this large file, then reduce its size and save multiple copies of the image for other uses.

■ CHANGING RESOLUTION IN AN EMERGENCY

Sooner or later, insufficient resolution is going to cause you a big headache—you'll desperately want to make a huge poster or dramatically crop an image and just not have the pixels you need. Trust me—every digital imager has been there. It's such a common problem, in fact, that software has been designed specifically to cope with it. Genuine Fractals (www.lizardtech.com), pxl Smart-Scale (www.extensis.com), PhotoZoom and PhotoZoom Pro (www.truly photomagic.com), and plug-ins like SI Pro (www.fredmiranda.com) all provide high-quality upscaling.

3. THE BASICS: DIGITAL CAMERAS

If you are shopping for a new digital camera, the following are a few things to keep in mind. If you already have a digital camera you plan to use to do special-effects photography, read through this section and make sure you're familiar with your camera's controls for the features that are listed—you'll be using them throughout this book.

Webcams (top) fall into the minicam class. A point-and-shoot digital camera (middle) can produce excellent images. If you can afford one, a digital SLR (bottom) is a great choice.

■ TYPES OF CAMERAS

There are several types of digital cameras. You can use any type—and you don't need to use the latest model—but some types and models of cameras do offer features that make them more flexible than others.

Minicams. Minicams are now found in everything from cellular phones to PDAs. In the same class as these are webcams, which can take quick shots and video clips for online use. Some very low-end digital cameras (which take 640x480-pixel images) also fall into this category. These are lots of fun, but their limited controls reduce your creative options.

Point-and-Shoots. The most common type of digital camera is the point-and-shoot—the kind of camera that most nonprofessionals choose. This type of camera has a built-in lens, fully automatic exposure and focusing, and an image sensor (the "film" of the digital camera) in the 2- to 8- megapixel range.

Digital SLRs. Digital SLR (single-lens-reflex) cameras are the most common type used by professional photographers. Some of these models are now priced under $1000, though, making them a real option for many amateurs as well. There are two types: those with interchangeable lenses and those without. The ability to change lenses is a great asset, giving you the ultimate flexibility when creating your images, but these models are also higher in cost.

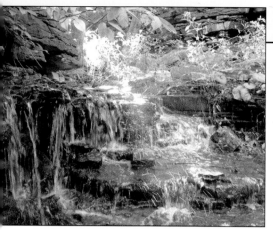 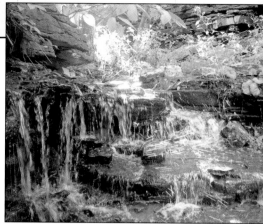

Something as simple as changing the white balance setting (here from daylight to tungsten) on your camera can totally change your image.

Digital SLRs usually have an image sensor in the 6- to 10-megapixel range (this number is increasing rapidly). They also offer more advanced metering and focusing features than point-and-shoot models and more flexible flash settings. Digital SLRs also offer manual focusing, aperture, and shutter control—letting you take total control of your images.

■ FEATURES TO LOOK FOR

Zoom Lens. It is helpful to use a model with a zoom lens, since this will give you the most choices when composing your images.

Exposure Modes. Also helpful is a full range of exposure settings (like a landscape mode, portrait mode, night-portrait mode, panoramic mode, aperture/shutter priority, etc.).

Manual Settings. Being able to select your aperture, shutter speed, and ISO manually is extremely helpful, as is the option to focus manually.

White Balance. Look for a model that gives you several white-balance settings (including the option to create a custom setting).

Burst Mode. Look for a model with a burst, continuous-shooting, or sports mode that lets you take a whole sequence of images with one push of the shutter button.

■ DOES BRAND MATTER?

All of the major camera manufacturers—Kodak, Sony, Fuji, Nikon, Canon, etc.—make excellent cameras, so shop by feature rather than by brand name if you decide to purchase a new camera.

4. CREATIVE OVEREXPOSURE

What makes one exposure setting "right" and another one "wrong"? A lot of it has to do with the way our cameras "see" scenes. However, cameras don't have brains (remember: your camera is *not* smarter than you!), so they can't creatively evaluate a scene.

Since most people just take their camera's word for it, though, and use the exposure setting picked by the camera, one of the easiest ways to make an image look a little bit different is to use an "incorrect" setting. This could mean overexposing the image (making it lighter) or underexposing the image (making it darker, as discussed in lesson 5). Essentially, what you're doing is redefining what makes the exposure setting "proper" as "what actually makes my subject look great" instead of "whatever my camera decides."

There's nothing wrong with the exposure the camera selected for this portrait, but people often look better a bit overexposed (or a lot overexposed, as on the facing page). Here, the Burn tool in Photoshop Elements was used to darken the eyes and glasses for more drama. This technique is often used in fashion photography.

■ HOW TO OVEREXPOSE AN IMAGE

In Camera. You can overexpose an image when shooting by using the manual exposure settings to select a wider aperture (a lower f/stop number), a longer shutter speed, or a positive exposure compensation setting (+1 or +2 stops will usually be enough). Shoot the image and check out the preview, then refine your settings until you get just what you want.

With Software. In Adobe Photoshop Elements, you can "overexpose" an image after the shoot by going to Enhance>Adjust Lighting and picking Brightness/Contrast. Adjust the sliders to the right of center until you like the results you see.

■ FINISHING TOUCHES

Sometimes, overexposing an image will negatively effect some areas of the subject. Using the Burn tool in Elements can rectify this. In this example, the Burn tool was used to slightly darken the eyes, sunglasses, and lips for a better look in the final image. You could also use the Brush tool in the Color mode (set in the options bar) to add color to the image.

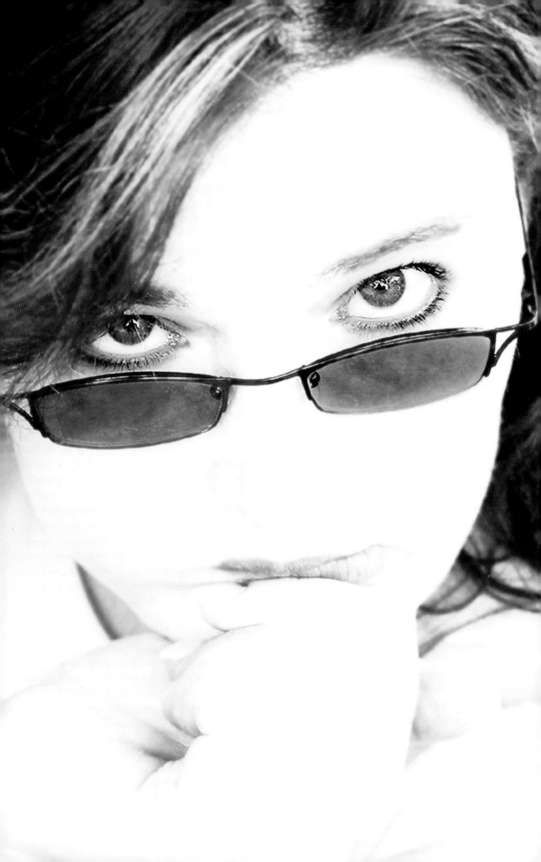

5. CREATIVE UNDEREXPOSURE

While some scenes look great overexposed, many subjects are at their best when they are rendered in an underexposure. The result is an image with darker tones that can suggest mystery or seriousness. It can even make the image seem very ominous or dramatic.

■ **HOW TO UNDEREXPOSE AN IMAGE**

In Camera. You can underexpose an image when shooting by using the manual exposure settings to select a smaller aperture (a higher f/stop number), a short shutter speed, or a negative exposure compensation setting (–1 or –2 stops will usually be enough, but you can also experiment with more dramatic settings). Shoot the image and check out the preview, then refine your settings until you get just the results you want.

Exposure Lock. Night scenes (see lesson 6), stormy skies, and sunrises/sunsets often need to be underexposed to look as dramatic as we'd like them to in our images. You can use one of the techniques described above, or employ your camera's exposure-lock feature. To to this, meter for the brightest part of the sky, lock in the exposure, then re-compose your image and shoot. Again, evaluate the results on your digital camera's LCD screen. If the image is too dark or too light, meter from a different area of the scene, lock it in, and shoot again.

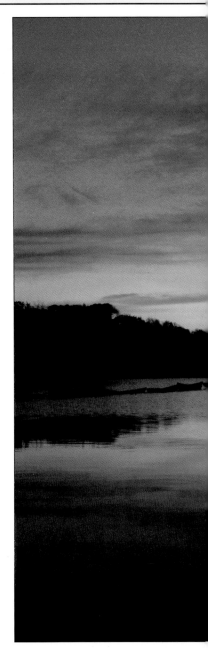

■ **SILHOUETTES**

In high-contrast scenes, underexposure can be used to produce silhouettes, as seen in the sunrise image above. This shot was actually about two stops under-

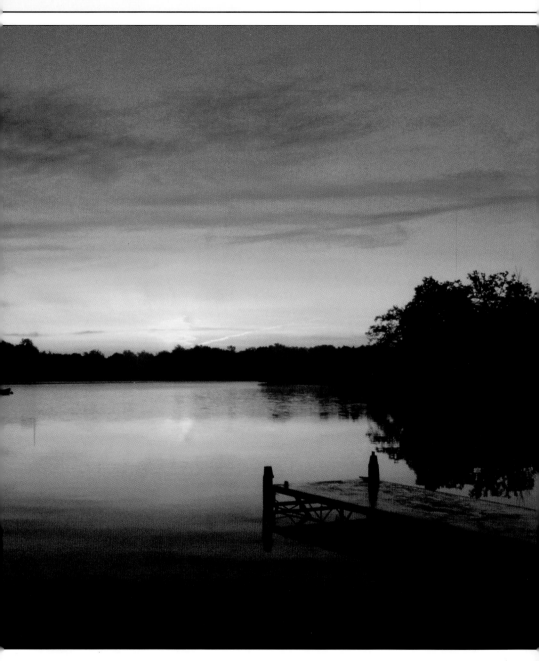

exposed, rendering in vibrant tones the colors in the sky (which were actually much more subtle and pastel that morning) and leaving everything else in the scene completely black.

6. NIGHT SHOTS

Night images really require underexposure to look their best—with rich, dark blacks and bright sparkles of light. But why stop there? Combine the ideas below with the underexposure techniques discussed in lesson 5.

Adding a star filter (many different kinds are available) turns bright light sources in your image into starbursts. The results can be subtle (as seen below) or extremely dramatic, with long trails extending out from every light.

At night, the movement of cars and other vehicles can be rendered as streaks of light—the longer the shutter speed, the longer the light trails. Some trial and error will usually be required to get the streaks right where you want them in your image, but the results can be dramatic. In the image on the facing page, the streaks were from the windows and lights of a city bus.

7. HIGH CONTRAST

Most digital cameras give you the option to adjust the contrast setting of your image before you take the picture. Consult your camera's manual for how to access this control on your camera. In almost every situation, you'll want to leave this control off or at its lowest possible setting. This gives you the greatest possible range of colors and tones in your image

If you increase the camera's contrast setting, the result will be darker shadows, brighter highlights, and vibrant colors. For even more kick, check your camera for a color saturation setting (sometimes called "vibrant colors"). This can be a nice effect for all kinds of images where you want some dramatic flair.

It's very easy to add contrast *after* the shoot when you can evaluate the image on your computer monitor and ensure you get just the results you want. With your software, you can also add effects that go *way* beyond the possible in-camera enhancements, as seen on the facing page. In Photoshop Elements, just go to Enhance>Adjust Lighting>Brightness/Contrast and drag the Contrast slider to the right until you like the results.

With the camera's contrast enhancement set to none, the image (left) looks pretty much like the scene did. With the contrast setting enhanced, the colors are more dramatic (right). After the shoot, digital imaging software can be used to produce even more dramatic contrast (facing page).

8. LOW CONTRAST

While high-contrast images, as discussed in lesson 7, have their appeal, a low-contrast effect is sometimes just what you need to make a statement with your image.

In white-on-white situations, where (as seen on the facing page) the subject and background are both white or very light, keeping the contrast low can help create a sense of purity, delicacy, and luminosity. To do this, get lots of soft light (light that doesn't cast harsh shadows) on your subject—light from an overcast sky or through sheer curtains on a window works well. Then, overexpose your image slightly (see lesson 4 for tips on doing this). If the results still have too much contrast, use software to reduce the contrast (in Photoshop Elements, go to Enhance>Adjust Lighting>Brightness/Contrast and drag the Contrast slider to the left until you like the results.)

Low-contrast effects are also good for many foggy, cloudy, or smoky scenes. These factors naturally reduce the contrast of a scene, so you should have no problem capturing a low-contrast image just shooting as you regularly would. Try a few exposure settings until you get the look you want.

One warning: low-contrast scenes can make it hard for your camera to focus automatically, so be prepared to switch to manual focusing if need be. Consult your camera's manual for how to do this.

Low-contrast effects are helpful for conveying the beauty of cloudy scenes (above) and the luminosity of white-on-white subjects (facing page)

9. SELECTIVE FOCUS

As humans, we are used to seeing the world in focus—from the hand six inches in front our face to the far-off mountain peaks. When we don't see the same thing in photos, it can be confusing. As photographers, however, we can use that to our advantage, showing our subjects in ways that our viewers simply *can't* see them with their eyes.

This is not to say that you can totally forget about focus. If you do, don't expect your viewers to sit through more than a few images before they get a headache or become extremely suspicious of your skills as a photographer. For most subjects, it makes sense for at least *some* part of the scene to be in focus.

What is not necessary, though, is for *every* part of *every* scene to be in focus. This technique, called selective focus, is an effect often used by advertising photographers—especially when photographing food and other small items. It's also used by portrait photographers who want a contemporary look in their images.

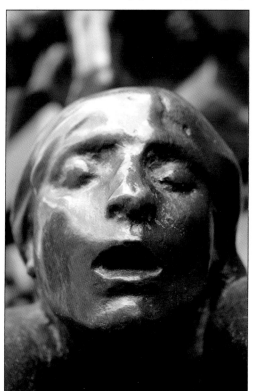

This detail from Rodin's *Gates of Hell* was made using the camera's super macro setting, which naturally produces very little depth of field.

■ HOW TO DO IT

The quickest way to blur some of your subject is to switch to the portrait mode, instantly setting the camera to a wide aperture that will blur everything except what you specifically focus on.

Alternately, you can switch over to the aperture-priority mode and select the widest available aperture (the smallest f/stop number).

Focus carefully on the area you want to keep in focus (for instance, in a portrait, focus on the subject's eyes), press the shutter button halfway down to lock the focus, then re-compose and shoot.

10. CAMERA MOTION

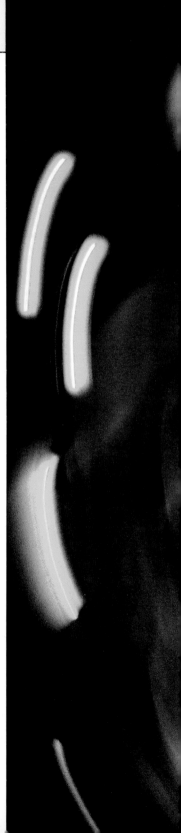

Usually, you want your photos to come out sharp. In fact, images that *aren't* sharp are often viewed as mistakes. However, a little creative camera movement can create an image that is very compelling—even when it's totally blurry or only partly sharp.

■ SHUTTER SPEED

For best results, elongate the shutter speed by setting your camera to the lowest ISO and using the smallest aperture (switch to the manual mode to make these adjustments). If this doesn't allow you to use a sufficiently long shutter speed to register the camera motion, consider using a neutral density filter. Some digital cameras have these built-in so they can be accessed through on-screen menus. If yours doesn't, you can purchase a traditional glass neutral density filter to go over the lens. This filter absorbs some of the light from the scene, making it possible to use longer shutter speeds without overexposing your images.

■ MOVE THEN SHOOT

When you're ready to try a shot, frame the image loosely, and prefocus the image by holding the shutter button halfway down. Then, begin moving the camera and press the shutter button to make the exposure while continuing to move the camera. You can use a long sweeping motion, an irregular jittery shake, you can spin the camera—whatever you like. Don't be surprised if you need to try this a few times to get it just right.

For this image, the subject held a string of lights over her head. Working in a dark room to maximize the shutter speed, the camera was twirled to render the lights as streaks.

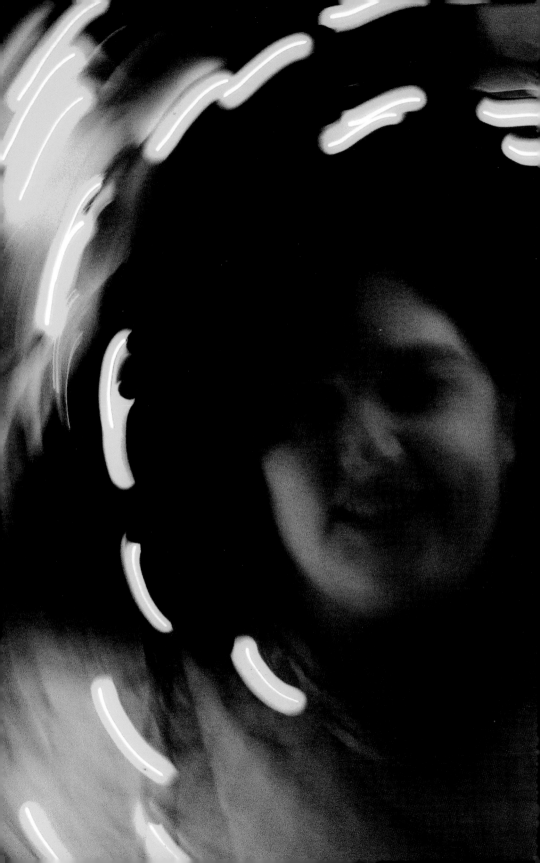

11. PANNING

Panning means following the action of a moving subject with your camera as you take the shot. If everything works out just right, you'll end up with a sharp subject against a streaky, blurred background, as seen to the right.

This technique is simple in concept, but it can actually take some practice to get the hang of it—especially if your camera has any kind of significant shutter lag (a delay between when you push the shutter release and when the photo is actually taken). With a little perseverance, though, you'll get it just right. Still, this is definitely a good time to shoot several images to ensure your results.

For this type of image, it also helps to select subjects where you'll have more than one shot at the perfect image (race cars on a circular track, kids on a sports field, etc.).

FAKING IT

If you can't get the panning action quite right, you can also create the same look using most digital image-editing software. Start with a picture where everything is sharp, then select the background area and apply a motion blur filter (for detailed instructions on this, consult the user's manual for your specific software).

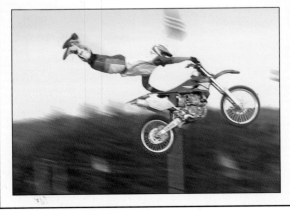

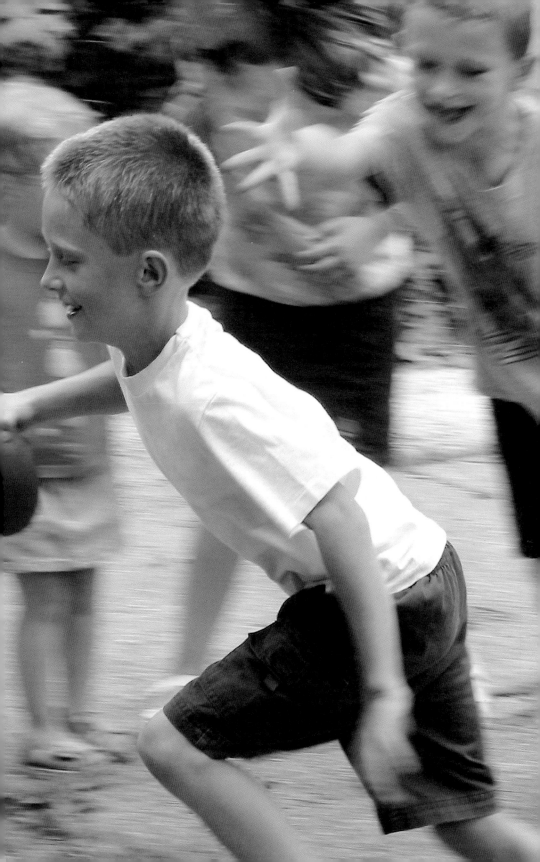

12. LONG EXPOSURES

To blur a subject, like the river on the facing page, you need to use a long shutter speed. You can use the manual or shutter-priority mode on your camera to do this. A shutter speed in the ½- to 1-second range will usually be fine. If you have trouble getting the correct exposure with this long shutter speed, try setting your camera's ISO to its lowest value (making the image sensor less sensitive to light) or adding a neutral-density filter over the lens (reducing the overall amount of light entering the camera). Shooting from a tripod or other camera support is critical for this type of image—if you don't, all the motion in your shot will probably be from camera shake. See lesson 11 for more on blur effects.

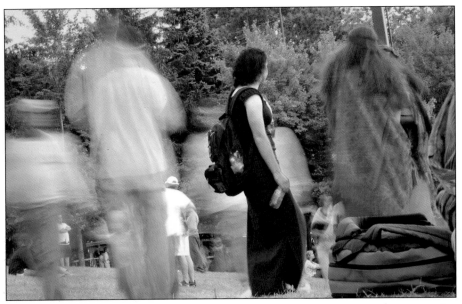

Using a long shutter speed, you can capture some interesting crowd shots. People who are moving will blur, while those who are standing still will be sharp.

FREEZE!

To freeze a subject you need to use a short shutter speed. You can use the manual or shutter-priority mode on your camera to do this. A shutter speed in the $\frac{1}{250}$- to $\frac{1}{500}$-second range will usually be fine. With these shots, timing is critical. You'll need to anticipate the action and press the shutter button just as it starts. Alternately, you can set your camera to the sports or continuous-shooting mode, then press and hold the shutter button to shoot a sequence of images. This helps ensure you won't miss the critical moment.

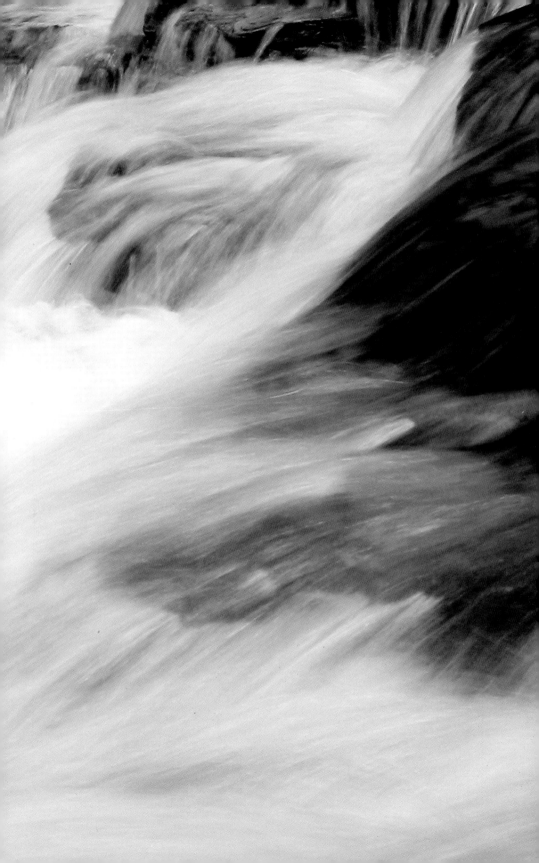

13. LENS FLARE

When a bright light source is in the frame (or very close to being in the frame), lens flare can be the result. This is characterized by a loss of contrast (washed-out areas) and bright spots (usually a string of small circles in a straight line).

Lens flare is almost always something to be avoided, but it can occasionally be used for an interesting special effect. It is often effective when you want to show the harsh glare of a light source—this could be the sun, a theatrical spotlight, or some other source. In movies, in fact, you've probably seen exactly this effect used to show the intensity of the environment when a character is crossing a desert

Use lens flare sparingly (it can quickly look gimmicky and lose its impact). Before shooting such images, you should also consult your digital camera's manual; some recommend avoiding this technique due to potential damage to the image sensor.

POLARIZATION

While we have our cameras pointed toward the sky to discuss lens flare, we should also take a moment to look at polarizing filters.

In addition to minimizing glare on many reflective surfaces (like water), polarizing filters can make ho-hum skies really come to life, as seen to the left. Used in moderation (i.e. not every outdoor photo you take), this can be a very eye-catching effect, since it produces colors that far outpace the intensity of the real thing.

When purchasing a polarizing filter for your digital camera, be sure to select what's called a "circular" polarizer; this will work most effectively with your camera's autofocus system.

With the filter in place, compose your image, then rotate the filter until you like the polarization effect you see.

14. STROBOSCOPIC IMAGES

Using a strobe light to illuminate your photographs lets you create multiple images of a moving subject in one frame.

To do this type of shot, you'll need to work in a totally dark room. You'll also, of course, need a strobe light. These can be found at most party supply stores. It's helpful to purchase one with a control that lets you adjust the speed of the flashing light. Finally, you'll need a black backdrop; for the shots here, a black velvet curtain was simply tacked up on a wall and allowed to drape down over a table.

When it's time for the shoot, start with your camera's aperture at a narrow setting (say, f/8); this will help minimize focusing problems, which can be an issue. Select a shutter speed of one second (and be sure to shoot from a tripod or place your camera on a steady surface). Adjust the strobe light to a medium flash rate. Set your subject in motion and click the shutter.

It will probably take a few tries to get a good shot. If you like, adjust the flash rate of the strobe and evaluate the results. You can also increase or decrease the shutter speed to get fewer or greater subject renditions.

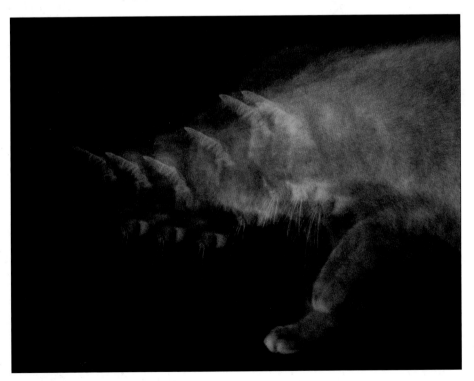

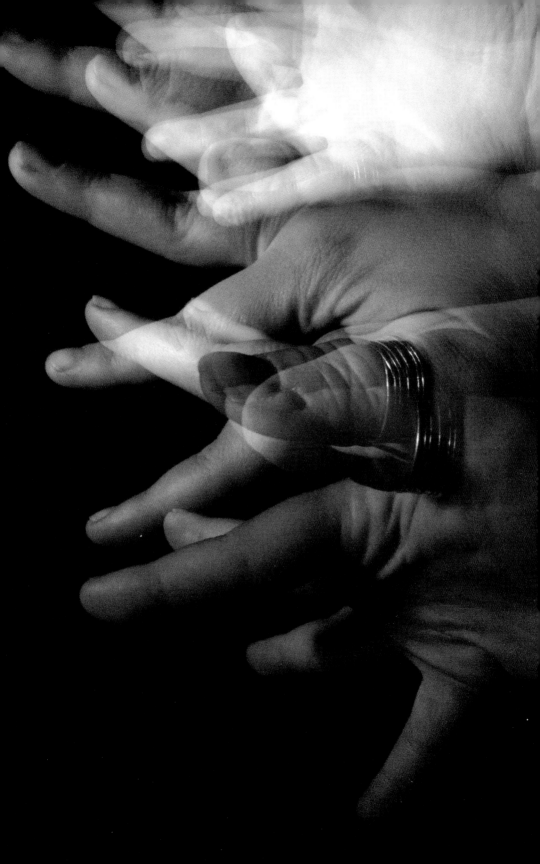

15. PROJECTED IMAGES

Avery versatile way to create a special effect is to project an image onto a three-dimensional object. All you need to do this is a projector of some sort, a black backdrop, and a light-colored subject.

To project your image, you can use a digital projector (as shown in the setup shot below), a traditional slide projector (which can be a great way to breathe new life into some old family slides), or even an overhead projector. You'll also need a table or chair to set this on that is at about the same height as your subject.

The most dramatic results are achieved when using a black backdrop (here, a black velvet curtain). This is because, if you use a very light-colored subject, the projected image will not reflect sufficiently to appear in the final image. This makes your subject look like it's floating on the backdrop. If you prefer, you can use a light-colored

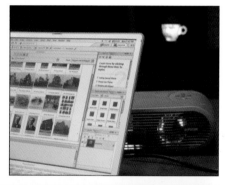

Building a projection setup is easy. All you need is a digital projector and laptop (or slide projector and slides), a dark backdrop and a light colored subject, here a white tea cup.

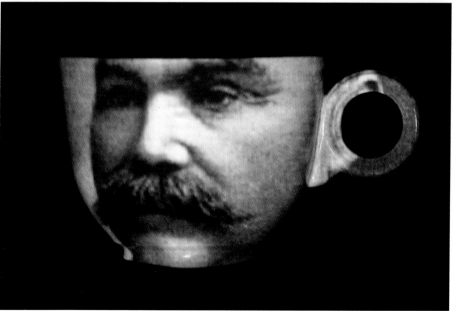

34

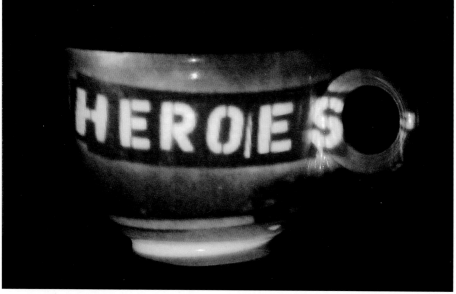

backdrop, in which case your subject will be wrapped in and surrounded by the projected image.

A white or very light-colored subject works best for this kind of setup, since it will most efficiently reflect the projected image.

Once you have everything in place, experiment with exposure settings on your camera and focus/enlargement settings on the projector until you get just the look you want.

16. BLACK LIGHT IMAGES

Light that is visible to the human eye is the source of illumination used in most photography, but there are other types of light, too. One of the easiest to photograph is long-wave ultraviolet light, also known as black light.

When buying a black light, look for a fluorescent tube that is designated BLB (black light blue). These have a built-in filter that prevents most of the visible light from being transmitted, producing a more dramatic effect.

To create an effective image, you'll also need a dark room to work in and, if possible, a very dark background for your subject (a black sheet will work; black velvet is even better). This can make it tricky to focus, so you may want to have an assistant on hand to turn on the room lights so you can lock your focus, then turn them off so you can make your exposure.

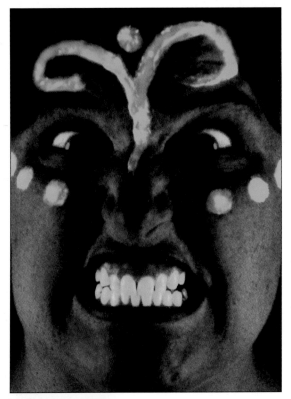

Once you have your shooting area ready, look for some subjects. Many art supply stores sell fluorescent crayons, paint, and paper. At theatrical supply stores you can find fluorescent makeup for some amazing portraits. You may even have things around the house that will work—tonic water, laundry detergent, postage stamps, new U.S. twenty-dollar bills, tooth whiteners, petroleum jelly, or even vitamin B-12 (crush it up and dissolve the powder in vinegar for a solution that glows bright yellow).

For the rather scary portrait seen above, the subject was made up with petroleum jelly. You can't see it in daylight (left), but it glows under black light. After the shoot, the contrast was increased using Adobe Elements to make the effect even more bold. Tonic water (facing page) glows bright blue under black light.

17. INFRARED PHOTOGRAPHY

In addition to black light (see lesson 16), you can use infrared light to take digital photographs. These images often have an eerie effect, with pale foliage and dark skies.

The first step is to ensure that your camera is capable of capturing infrared light. Fortunately, finding out is easy—simply point your television remote at your digital camera and press any button. If you can see the glow of the infrared beam in your camera's LCD, or if it is visible in the final image, then the camera is sensitive to infrared. The brighter and clearer the projected beam, the better the camera will be able to capture infrared images.

The key to taking infrared photos blocking out the visible light—otherwise, the infrared "effect" would be overwhelmed by the much more powerful visible light. This is done by using a filter. Which filter to use is hotly debated, varying from yellow (the least intense), to orange, red, and opaque (a filter that blocks all the visible light and provides the most intense effect).

The more sensitive the camera is to infrared, the less intense a filter is necessary to achieve an acceptable image. Exposure is another factor. If you use a

Photographed using infrared light, foliage turns pale gray. Photograph by Patrick Rice.

Blue skies are rendered as dark gray in infrared—and notice the grass! Photograph by Patrick Rice.

more intense filter, blocking out more of the visible light, you'll need to use a higher ISO setting, a wider aperture, and/or a longer shutter speed. This can present problems. As the ISO setting is increased, your images will look more grainy. As the aperture is increased, the amount of the image that will be in sharp focus will decrease. As the shutter speed increases, it becomes more difficult to control camera and subject movement. Therefore, many photographers use orange or red filters to maintain more moderate settings.

Infrared images are typically shot with the camera in black & white mode, but you can also experiment with other color settings.

For more information on this fascinating technique, read *Digital Infrared Photography* by Patrick Rice (Amherst Media, 2005).

18. DIGITAL PINHOLE PHOTOGRAPHY

Today's cameras, digital or otherwise, all use lenses to focus light onto an image-recording device—but you can use a pinhole for the same purpose. This technique has actually been in use for a long time. In the sixteenth century, artists developed something called a camera obscura, a portable darkroom used to project an image onto paper where it could then be traced. In the seventeenth century, Vermeer is thought to have used this type of device for many of his paintings.

In the digital age, pinhole photography remains an popular pursuit among photo enthusiasts, producing images with a unique perspective and, often, a soft, dreamlike quality that is very appealing.

To create your own digital pinhole photographs, you'll need a digital SLR camera and an extra body cap (the cap used to cover the lens mount when no lens is attached). Cut or drill a hole in this, then cut a thin piece of tin (or other metal) to fit over it. In the metal, punch or drill a tiny hole. Then, mount the metal on the body cap, using black tape to ensure light can pass only through the pinhole. Attach the body cap to your camera and start experimenting. If you prefer a less messy approach, you can also purchase laser-drilled body caps for many digital SLRs from Lenox Laser (www.lenoxlaser.com).

A soft, dreamy look is typical of digital pinhole photos. Photograph by Mark Beck.

Be prepared for some trial and error—especially when it comes to exposure. Because the pinhole is so tiny, long shutter speeds are required to create a good image. As a result, you'll get the best results with scenes and subjects that stay put and are brightly lit. You'll also need to use a tripod or find a solid place to sit your camera for these long exposures. If you like, you can also bump up the ISO setting on your camera, but keep in mind that this can create excess noise that can make your images look too soft.

Pinhole photographs can provide new perspectives on ordinary objects. Photographs by Mark Beck.

19. REFLECTIONS: BODIES OF WATER

If you are shooting around water—a lake, a river, even a birdbath—look for ways to create special-effects images using reflections.

Water is a natural mirror and can make a beautiful scene twice as interesting if you include the scene *and* its reflection in the frame, as seen in the image below, which was taken on a tranquil day. With such images, make sure to keep the horizon straight (perfectly horizontal). Centering it top-to-bottom in the frame will help to emphasize the symmetry between the scene and its reflection.

When ripples are present on the surface of the water—especially smooth, glassy ripples—you can photograph just the reflection itself (as seen in the image to the right) to create an abstract image with a watercolor effect. (Of course, you can also show the subject as its rippled reflection, as in the far-right image on the facing page.)

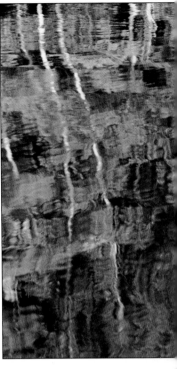

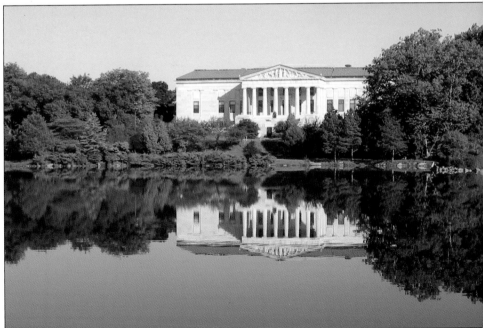

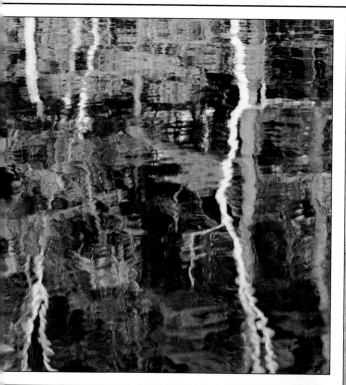

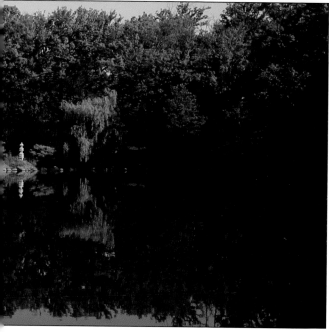

The surface texture of the water will determine whether the reflection you see is a clear mirror image or more of an abstract representation of the scene.

20. REFLECTIONS: ABSTRACT

Reflections can be found in lots of existing situations, such as on water as seen in lesson 19. It's also easy, however, to construct interesting reflections and create fascinating abstract images—all you need is a reflective surface, a good subject (a colorful one works well), and some patience.

■ TIPS FOR ABSTRACT REFLECTIONS

Select a Reflective Surface. The material you use will, to a large extent, determine your results. As with reflections on water, look for a smoother surface for less distortion; choose a more textured one (maybe even one with a pattern) for more abstract looks. Try mirrors (even broken pieces of mirror—while exercising great care, of course), aluminum foil, sheets of silver mylar, or whatever else comes to mind.

Position the Subject. Once you select a subject, position it so that it is reflected on the surface. Turn it a few times and evaluate the best position before shooting. You may also want to try tilting the subject and moving it closer or farther from the reflecting surface.

To create the image seen on the facing page, a sheet of mylar was taped to a wall and allowed to run down across the table-top. Two silk flowers were arranged on top of a pedestal to create a reflection in the mylar. Using the macro setting on the camera (see lesson 25), a close-up image was created.

Stay Out of the Picture. Place yourself and the camera at an angle to the reflective surface. Check that no likeness of yourself appears in the reflection, unless you're creating an abstract self portrait, which can certainly be a fun project—especially for kids.

Avoid Flash . . . or Don't. You'll probably have the best results using the room lights rather than your on-camera flash—but there's no reason you shouldn't experiment with flash!

Focus. Depending on the surface, you may have some trouble focusing. If need be, switch to manual focus (if your camera offers it) or focus on a nearby object that is at the same distance from the camera as the reflective surface. Lock in the focus, then reframe the final shot.

21. REFLECTIONS: MIRRORS

Mirrors are a great tool for creating special effects images—but don't limit yourself to just one type. Look for mirrored surfaces that have different colors, textures, shapes, and conditions and you'll find a wide variety of creative options.

■ BROKEN MIRROR

For the image on the facing page, a mirror was broken. The shards of glass were removed from their frame and reassembled on a thin piece of plywood using double-stick carpet tape (which has a very strong adhesive). This allowed the broken mirror to be maneuvered freely without worry of the glass falling out. If you try this, be sure to wear protective eyewear and gloves. You may

also want to run duct tape around the edge of the reassembled mirror to reduce the potential for getting cut while handling it. When the mirror was complete, an assistant held it up in front of the statue. By standing at an angle to the mirror, you can photograph the reflection without getting yourself in the frame.

■ SUNGLASSES

The image to the left was actually created by shooting into a pair of tinted mirrored sunglasses. Their convex lenses caused the bending effect and the tint colored the entire scene.

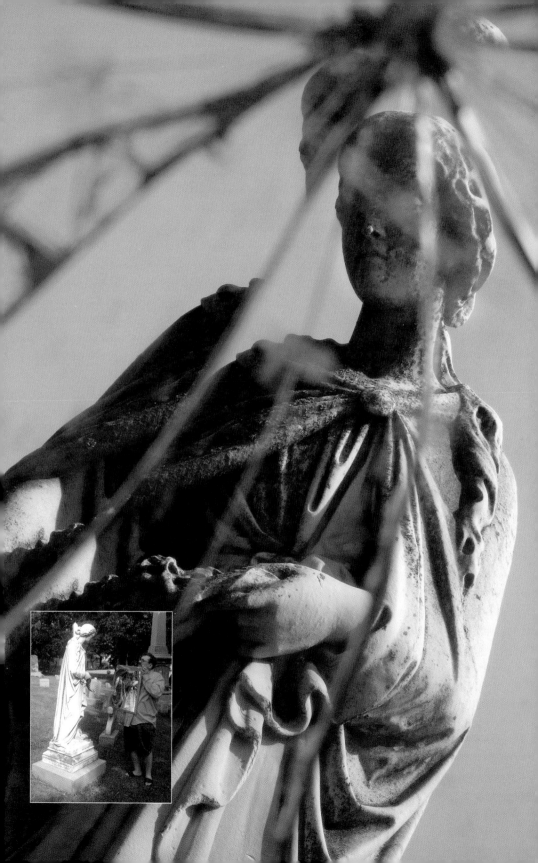

22. SPECIAL EFFECTS FILTERS 1

Photographic filters are specially designed pieces of glass (or other material) that can be placed over or in front of the lens to alter the light entering the camera. These can instantly produce image effects that range from subtle to outlandish.

Most filters designed for use with film cameras will also work with digital cameras (although some people feel that you lose some of the subtle effects when shooting digital). So if you have a slew of filters packed away with your old film photography equipment (or know someone who does), dig them out and give them a try.

Before heading out to buy new filters, take a minute to check your camera's manual. You may need to purchase an adapter tube that will hold the filter out in front of the lens as it zooms in and out.

Soft focus filters (also called diffusion filters) produce a hazy look that is often flattering for portraits. These filters come in various grades, with effects that range from barely visible to a deep, dreamy haze. You can also find soft focus filters with a clear area in the center, allowing you to create an image with a sharp area in the center surrounded by a soft and hazy background.

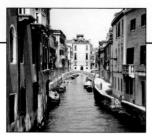

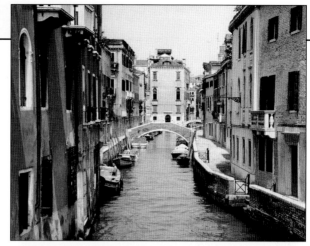

Sepia filters instantly transform color scenes, producing an old-time photo look. Many digital cameras have a built-in sepia mode that you can use instead of this filter—or you can produce the look using your image-editing software.

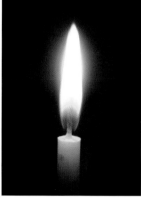

Star filters produce rays that radiate out from any bright points of light in the image. Try them with photographs of candles, holiday lights, bright reflections on water, street lights, the sun, and more. The variety of filter you choose will control the number of rays that radiate out and you can control the direction of the rays by rotating the filter.

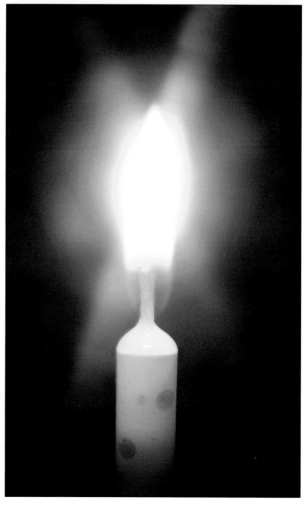

23. SPECIAL EFFECTS FILTERS 2

Special effects filters vary widely, but there are some basic types. In the previous lesson, you saw an example of a soft focus filter in use. These filters (also called diffusion filters) produce an image that is sharp but with slightly blurred highlight areas. Other filters, like the sepia filter also shown in the previous lesson, produce color effects that can be quite pleasing. Star filters are made of etched glass that produces rays of light extending out from the highlights in an image—in some cases, the rays may even be rainbow tipped! Multi-image filters, as the name implies, produce a kaleidoscopic effect with multiple renditions of the main subject in a single exposure. For more on special effects filters, check out *Photographer's Filter Handbook* by Ron Eggers and Stan Sholik (Amherst Media, 2002).

Multi-image filters create multiple images of the main subject in a circular pattern, as seen here, or in a repeating parallel pattern. Photo by Ron Eggers.

A speed filter produces streaky lines around your subject, simulating the look of motion.

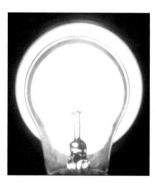

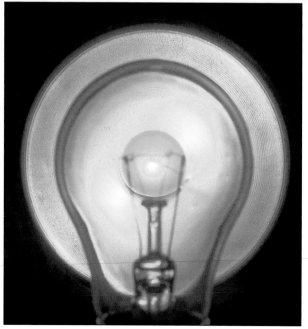

The subject of this image is a clear light bulb held in front of a utility light with a regular household bulb in it. Adding a red filter (right) produces a dramatically different look.

24. MAKE YOUR OWN FILTERS

For those of you who are a little more ambitious than the average photographer, an adventure in do-it-yourself filters can be quite rewarding—just be prepared for both successes and failures (as well as some intriguing images).

■ BE EXTREMELY CAREFUL!

Before you begin devising your own special-effects filters, keep in mind that the lens is one of the your camera's most vulnerable components. At all times, your top priority must be not to jar, scratch, or mar it in any way. In fact, it's a very good idea to invest in a protective filter for your lens (and leave it on even when you're not monkeying around with custom-built filters). A filter made of clear photographic glass puts a barrier between your lens and the rest of the world without affecting focusing or exposure.

■ GET CLEVER

Basically, the sky's the limit when it comes to devising accessories to shoot through. Your filters can be as simple as clear pieces of cellophane (or other materials) hooked over the end of the lens with a rubber band. You could build a cardboard "adapter" box that fits over the lens and holds who-knows-

To create a unique diffusion filter, you can use a rubber band to attach a sheet of bubble wrap over the camera's lens. To keep a small area of sharp focus in the center of the image, cut a tiny hole in the wrap and center it over the lens when attaching the sheet. The image on the left was taken without the filter; the one on the right was taken with the filter.

For this image, star-shaped stickers were applied to a sheet of clear plastic wrap. This was then placed over the lens and held in place with a rubber band. The stars show up as silhouettes in the final image (right). The plastic wrap also gives the image a soft, diffuse glow.

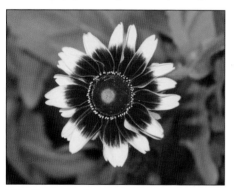
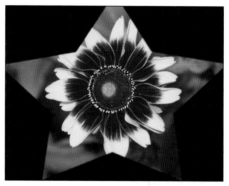

This filter is really more of a vignetter, a device used to darken the edges of an image. To create this star vignette, a small star shape was punched in a piece of black poster board. Shooting through this opening created a black frame around the flower.

what in a slot at the end. You could obtain two commercially-manufactured clear glass filters and sandwich your filter materials between them, then attach them to the camera as you would any other filter. You could even experiment with simply holding your filter material in front of the lens.

■ SHOOTING

All bets are off when it comes to shooting with homemade filters. You should anticipate some challenges when it comes to both exposure and focusing. The best approach is to experiment and check your results on the LCD screen. If your camera allows it, zoom in on the image preview to check the focus of each shot.

25. DRAMATIC CLOSE-UPS

A s humans, there are certain limits to the ways we can see things. Of course, we can back away from a scene to get a broader view, or lean in close to a subject to see more detail—but, in most cases, we simply don't take the time. That's what makes close-up shots (and very wide-angle images; see lesson 31) so eye-catching and appealing.

■ MACRO AND SUPER-MACRO MODE

Fortunately, digital has made close-up shots easier than ever to capture. The key is to look for the close-up or macro mode icon (normally a flower) on your camera. Without this setting, you may only be able to get to within a few feet of a subject before your autofocus stops working. With the macro setting active, however, you should be able to bring your lens to within a few inches of your subject and still get a crisp, well-focused shot. If your camera has a super-macro mode, you will be able to get even closer!

■ TIPS FOR CLOSEUPS

Avoid Flash. When working very close to a subject, be sure to disable your flash and work with the existing light in the scene. If you allow the on-camera flash to fire so close to the subject, you'll end up with a washed-out image.

Focus Carefully. As shown below, the depth of field in the macro modes is very limited, so precise focusing is critical. Check your images on the LCD screen (zoom in on the preview, if your camera allows) to ensure you've captured the results you want.

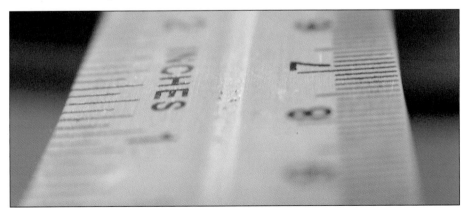

In the macro and super-macro modes, the depth of field (the zone of sharpness in the image) is very narrow. As you can see in this image of a ruler, less than a half-inch band is sharply focused.

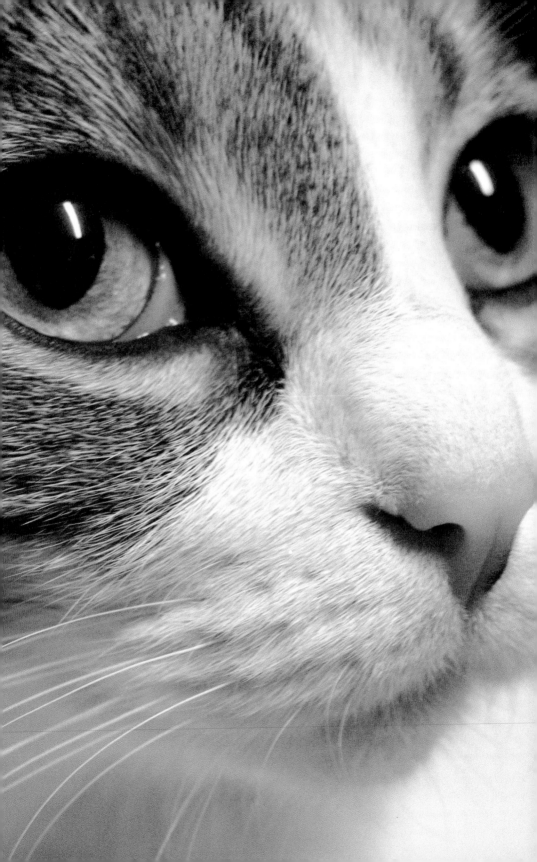

26. VERY HIGH CAMERA ANGLE

■ STREET SCENES AND LANDSCAPES

When most people photograph a street scene or landscape, they do so from ground or street level—it's just the easiest position (and, thus, the least spectacular). Instead, try looking for a vantage point and shooting down on the scene. The image on the facing page, for example, was taken from a 28th-floor observation deck. While you're up there, why not shoot a series of images for a panoramic photograph, too (see lesson 31)?

■ PORTRAITS

Shooting portraits from a second-story window or ladder can add instant appeal. Be prepared for some distortion, though—your subjects' heads may look disproportionately larger because they are so much closer to the camera than the rest of the body.

■ AERIAL PHOTOGRAPHY

Aerial images are best taken from small planes where you can open the window to shoot—but you can sometimes get interesting images through the windows of even commercial jets. It's worth a try!

You can take great high-angle shots of people from a window or ladder.

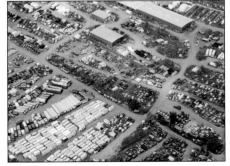
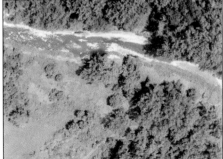

Aerial landscape photos show the world in a unique way—they are the ultimate in high-angle photography. Look for interesting patterns (like the rows of junked cars in the image on the left) and big or repeated features (like the river in the image on the right).

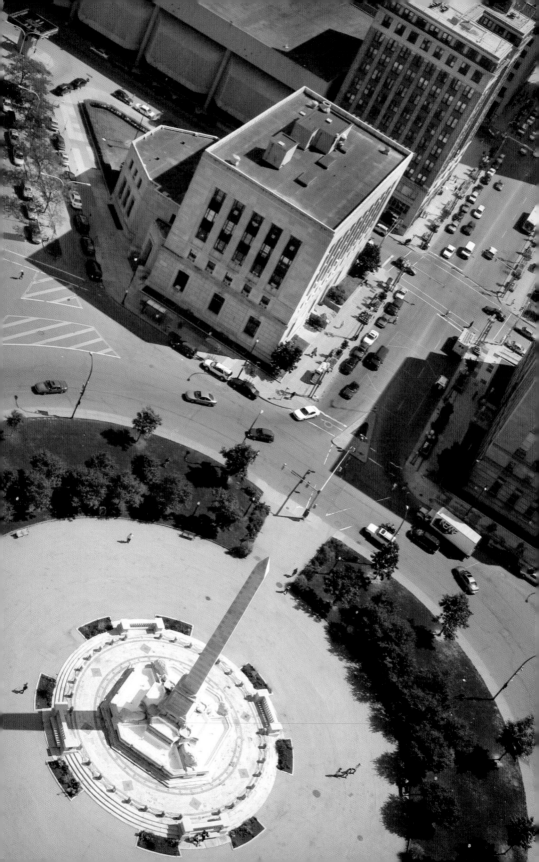

27. VERY LOW CAMERA ANGLE

Most people look at the world from a height of somewhere between five and six feet off the ground. As a result, most pictures are taken from that height. But there's no reason to be satisfied with this ho-hum approach.

Instead, trying getting down very low. Sometimes just shooting from waist or knee height can be enough to make your images stand out. You might even place your camera on the ground if you can do so without getting it wet or dirty. A plastic bag can be useful as a protective stage for your camera when you want to place it on a questionable surface.

Low camera angles work well with lots of subjects. They tend to make people, buildings, and other very vertical subjects look very tall. Even small subjects (like the mushrooms below) may seem to tower over the viewer when photographed from a very low angle.

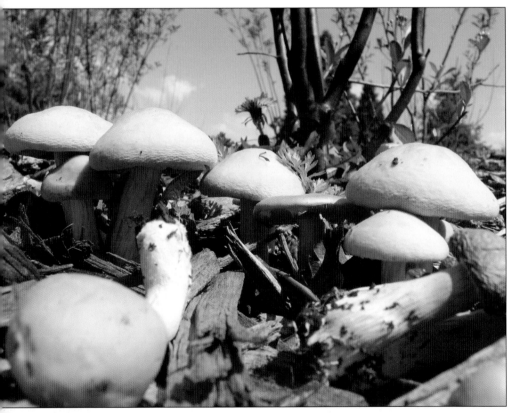

Whether it's small subjects, like the mushrooms above, or huge ones, like the towering tree on the facing page, getting a bug's-eye view can give your image a unique look that makes viewers stop to take a closer look.

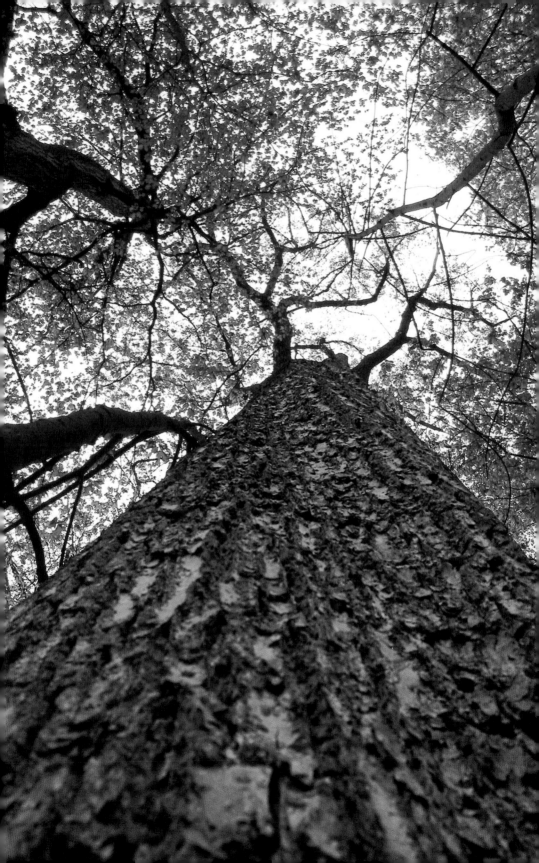

28. SILHOUETTES

Most subjects are best photographed when the sun is behind the camera and falls on the front of the subject. Because most photos are taken this way, though, using backlighting (light that comes from *in front of* the camera and falls *on the back of* the subject) can make your images stand out.

The challenge with this type of light is that if you expose for the bright background behind the subject, the front of the subject will be underexposed (very dark); if you meter for the subject, the background will be overexposed (very light). While this might sound like a problem, it's actually a situation with some interesting creative potential.

If you expose the image correctly for the subject (especially with bright backlighting), you can end up with a very interesting washed-out background. Naturally, this works to its best effect when the background isn't an important part of the image.

Silhouettes, on the other hand, are the result of backlighting taken to its opposite extreme. To create a silhouette, look for a backlit subject with a great

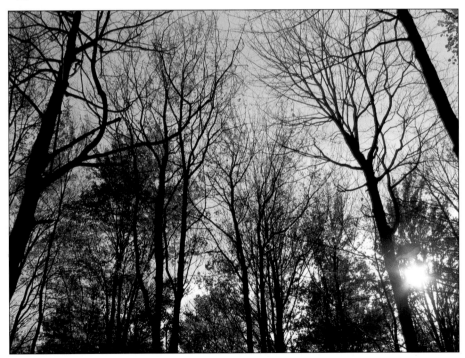

In some situations, backlighting can be used to create a very dramatic effect. In the image above, the sun (filtered through leaves) appears as a starburst at the lower right corner of the image and the autumn tree trunks are silhouetted against the blue sky.

Subjects with very geometric shapes often look great when silhouetted.

shape. Then, frame it so that all you see behind it is sky (maybe even a color-ful sunset!). Next, meter for a light area of the sky and expose the shot. Metering for the sky ensures that the subject will be rendered as very dark.

29. CREATIVE COLOR

■ **WHITE BALANCE**

With digital, the camera can balance the colors for accuracy under just about any kind of light (sunlight, fluorescent light, etc.). This is great for making colors look *right*, but you can also use it to make them look *wrong*—producing a color cast that adds dimension to a scene. To do this, consult your camera's manual for how to set the white balance. Then, pick a setting that doesn't match the conditions under which you are shooting. In the example below, the photograph on the left was taken under daylight and with the daylight white-balance setting. The photograph on the right was taken under the same light but with the tungsten white-balance setting, adding an icy blue cast.

■ **COLORIZED FLASH**

For a pronounced color effect, try adding some color to your flash. To create the large image on the facing page, a double layer of red cellophane was taped over the on-camera flash. To ensure that the red light had the maximum impact, the subject (a bouquet of white roses) was set up in a dark room with a dark background. As you can see, the result is an intense hue that overwhelms every color in the scene. For comparison, see the inset photo on the facing page; here, the unaltered flash was used to produce a color-accurate image. One tip for this technique: depending on your camera, you may have trouble focusing in a very dark room. If this happens, enlist an assistant to turn on a light so you can focus, then click it off for the exposure.

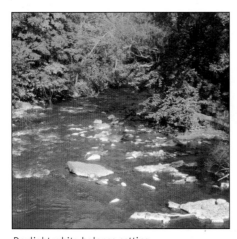
Daylight white-balance setting.

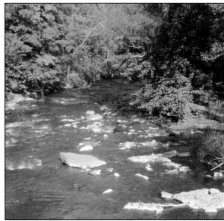
Tungsten white-balance setting.

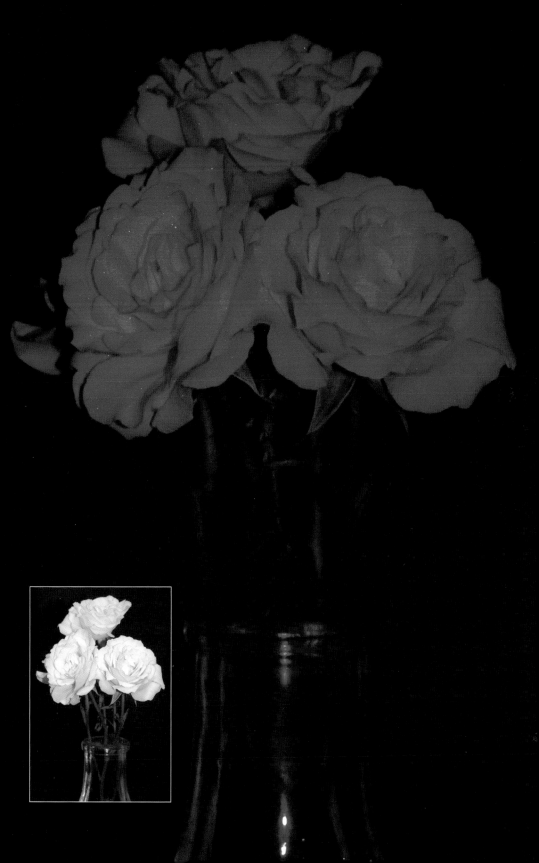

30. SOFTWARE

There are many programs on the market. Some are all-purpose tools that can do lots of common tasks. Others are single-function products that tackle one specialized task. Still others, called plug-ins, are like mini-programs that run from within a major application and add functionality to it.

■ ALL-PURPOSE

Adobe Photoshop Elements is a great bargain, giving you all but the most professional-level tools found in Adobe Photoshop (its big brother) but for about $500 less. To learn more, visit www.adobe.com.

Roxio PhotoSuite offers tools for correcting common photo problems and adding creative effects. To learn more, go to www.roxio.com.

ACDSee provides automated and manual tools for enhanced control over your photographs. It's a very popular program with lots of loyal users. For more details, visit www.acdsystems.com.

Microsoft PictureIt! features quick tools for enhancing lighting, correcting the color and composition of your images, and restoring old photos. For further information, visit www.microsoft.com/products/imaging.

■ SPECIALIZED

Several programs are available to help you turn a sequence of images into one gigantic one. PhotoVista Panorama, from iseemedia (www.iseemedia.com) is one such program; its sole function is the creation of panoramic images.

Original image.

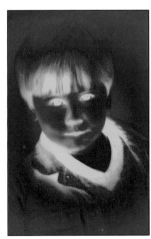
Nik Infrared plug-in.

Nik Solarization plug-in.

One popular type of digital-imaging software allows you to create virtual "albums" to be viewed on screen or printed out. Adobe Photoshop Album (www.adobe.com) is popular, as is Flip Album (www.flipalbum.com).

Some programs are devoted to special effects. A good example of this is Kai's SuperGoo (www.scansoft.com). This nifty program actually "liquifies" your photograph and allows you to smear, warp, and stretch it as you like.

Programs like Extensis pxl SmartScale (www.extensis.com) allow you to greatly increase the size of your images without any visible loss of quality.

Sharpener Pro from nik Multimedia lets you sharpen your images while tailoring your results to your intended method of output—whether you use your images online, with an inkjet printer, or in a fine-art book. For more information, visit www.nikmultimedia.com.

■ PLUG-INS

Plug-ins are small programs that run from within a major application (like Adobe Photoshop Elements) and are used to add a narrowly specialized function. Plug-ins can do all sorts of things: help you correct exposure; reduce grain in your images; correct for lens distortion; add artistic effects; simulate wind, rain, and snow . . . the list goes on! Below is a series of images created with plug-ins from nik Multimedia. Designed for photographers, the Color Efex Pro! package features over fifty plug-ins that create effects ranging from subtle to extreme. See www.nikmultimedia.com.

Nik Monday Morning plug-in.　Nik Old Photo plug-in.　Nik Sunshine plug-in.

31. PANORAMICS

Panoramic images are created digitally by shooting a sequence of images and then combining them into one photograph.

■ SHOOTING THE IMAGES

Planning is critical when making panoramics. If you are using a point-and-shoot with a zoom lens, set it about halfway out. It might seem like a good idea to use a wide-angle setting for panoramics, but this will cause distortion that makes the shots impossible to join together seamlessly.

When you start shooting, select one exposure setting and focus setting and stick to it. The idea is to create the impression of a single image, and that won't happen if some sections are lighter/darker than others, or if the focus suddenly shifts from the foreground to the background. It's also important to maintain a consistent camera height (for best results, use a tripod and rotate the camera as you take each shot).

Let's imagine you are standing facing the part of the scene that you want to have on the left edge of your final panoramic. Position the camera and take the first shot, noting what is on the right-hand edge of the frame. Pivot slightly to the right and place the subject matter that was in the right-hand part of the first frame just inside the left edge of the second photo. Continue this process until you've taken enough images to cover the desired area. Ideally, you should have about a 20 percent overlap between the images.

If your camera has a panoramic setting, switching to it will change the display on the LCD screen so that you can see the image you are about to shoot and the previous image side-by-side, making it easy to set up successive shots. For added interest, try including a person in each image, as shown below.

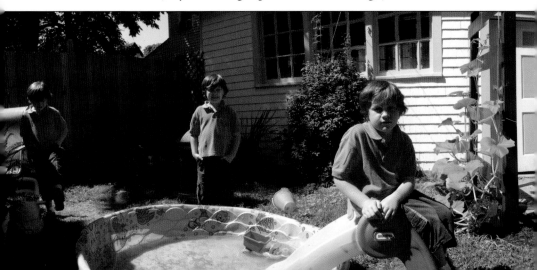

TIPS FOR PANORAMICS

When you aren't careful about your lens setting, focus point, and exposure when shooting your original images, the software won't be able to seamlessly merge your photographs into a unified whole. The results might initially look okay, but when you zoom in, the problems will be evident. Usually, the problem areas will look like diagonal lines where things just don't seem to match up properly. If these are fairly faint, you might be able to correct them using the Clone Stamp tool in Adobe Photoshop Elements. Sometimes, however, the problems are insurmountable and the only choice is, if possible, to reshoot the images. If you're shooting panoramics on vacation or somewhere that would be hard to reshoot, consider taking more than one series of images—just in case!

■ PHOTOMERGE

Once you've shot the images, combining them is a relatively simple procedure. Here's how to do it in Adobe Photoshop Elements. If you're using a different product, consult the manual for instructions.

Go to File>New>Photomerge Panorama. In the window that appears, click Browse and select the images you want to merge. When all of the files appear in the Source Files window, hit OK and watch things start to happen.

When the second Photomerge window appears, Elements will try to place all of the photos in the correct position. If it can't, the problem photos will appear as thumbnails at the top of the window. You can then drag them down into the main window and position them yourself. You can also click and drag the other images in the main window to reposition them if Elements doesn't do it correctly. When everything is in position, hit OK.

When the final image appears, it may have some uneven edges where the original photos overlap. Cropping the image will eliminate this and create the impression of a single photograph.

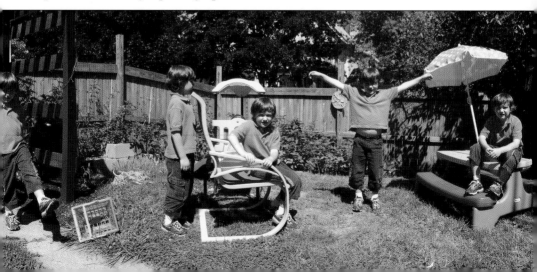

32. COLOR EFFECTS 1

In Adobe Photoshop Elements, there are lots of ways to transform the color in your images. One of the quickest is to go to Enhance>Adjust Color> Adjust Hue/Saturation. When the dialog box appears, simply click and drag the sliders until you like what you see. Under the Filters menu, you'll find a couple quick color-change tools in the Adjustments submenu. The Gradient

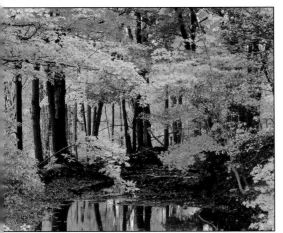

Map filter replaces the tones in your image with a smooth blend of colors you select. The Invert filter makes a negative of your image (magenta becomes cyan, black becomes white, etc.). This is a quick way to turn a "ho-hum" image into one that forces the viewer to take a second look!

The original image (left) was transformed using the Hue/Saturation tool (below), the Gradient Map filter (facing page, top), and the Invert filter (facing page, bottom).

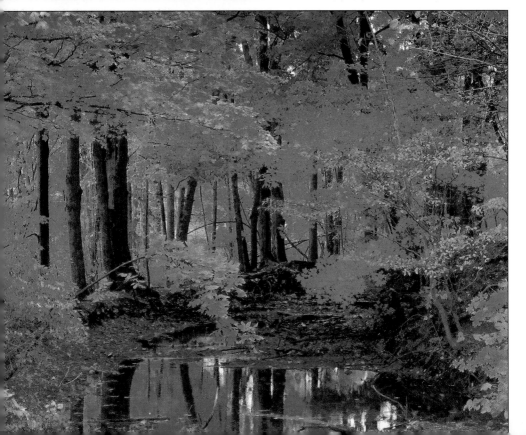

33. COLOR EFFECTS 2

Handcoloring photos is traditionally accomplished with a variety of artistic media—oil paints, pencils, etc. With Elements, you can create this classic look much more easily!

■ METHOD 1

This technique gives you total control over the colors you add and where you add them.

1. Open an image. If it's a color image, go to Enhance>Adjust Color> Remove Color to create a black & white image. If it's a black & white image, go on to the next step.

2. Create a new layer. Set it to the Color mode (top of the Layers palette).

3. Click on the foreground color swatch to activate the Color Picker. Select the color you want and hit OK.

4. With your color selected, return to the new layer you created in your image. Click on this layer in the Layers palette to activate it, and make sure that it is set to the Color mode.

5. Select the Brush tool and whatever size/hardness brush you like, then begin painting. Because you have set the layer mode to color, the color you apply with the brush will allow the underlying photo to show through.

6. If you're a little sloppy, use the Eraser tool (set to 100 percent in the Options bar) to remove the color from anywhere you didn't mean to put it.

The original image (left). The image handcolored using method 1 (right).

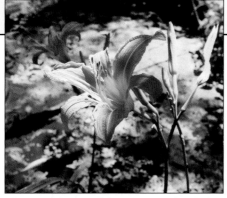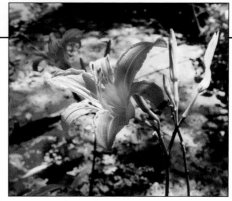

The original image (left). The image handcolored using method 2 (right).

Using the Zoom tool to move in tight on these areas will help you work as precisely as possible.

7. If you want to add more than one color, you may wish to use more than one layer, all set to the Color mode.

8. When you've completed the "handcoloring," your image may be either completely or partially colored. With everything done, you can flatten the image and save it as you like.

■ METHOD 2

Here's a quick way to add a handcolored look in seconds—or, with a little refinement, to avoid having to select colors to handcolor with. This technique works only if you are starting with a color image.

1. Begin by duplicating the background layer (by dragging it onto the duplication icon at the top of the Layers palette).

2. Next, remove the color from the background copy by going to Enhance> Adjust Color>Remove Color. The image will turn black & white—but by re-ducing the opacity of the new layer you can allow the colors from the under-lying photo to show through as much or as little as you like.

3. To create the look of a more traditional black & white handcolored image, set the opacity of the desaturated layer to 100 percent and use the Eraser tool to reveal the underlying photo. Adjust the Eraser's opacity to allow as much color to show through as you like.

4. For a very soft look, set the opacity of the desaturated layer to about 90 percent (just enough to let colors show through faintly) and use the Eraser tool (set to about 50 percent) to erase areas where you want an accent of stronger color to appear.

34. FILTERS: FOR ARTISTIC EFFECT

The filters that are most useful for creating special effects are those that either make your photograph look more like a painting (adding an artistic, natural-media look) or those that distort your image in more dramatic ways (see lesson 35). The best way to learn about these filters is to give them a try— just go to the Filter menu and select a filter from the pull-down list. Many filters have dialog boxes that let you adjust the effect; don't be afraid to click and drag the sliders a much as you want.

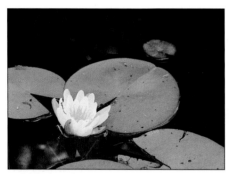
Original image.

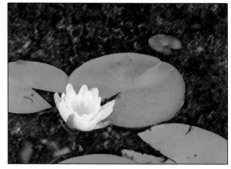
Colored Pencil filter.

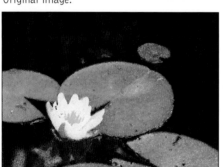
Dry Brush filter.

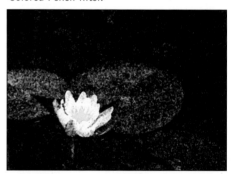
Fresco filter.

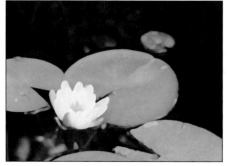
Paint Daubs filter.

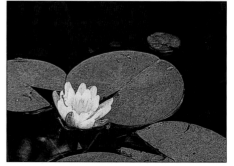
Poster Edges filter.

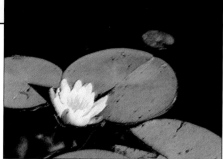

Rough Pastels filter.

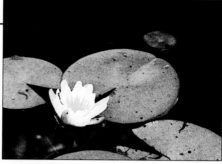

Smudge Stick filter.

Underpainting filter.

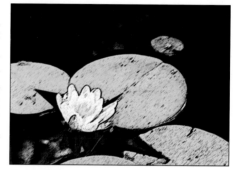

Sumi-e filter.

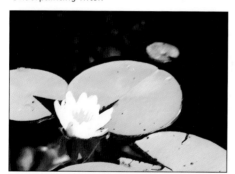

Dark Strokes filter.

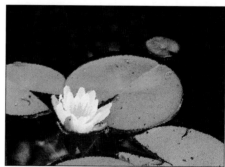

Sprayed Strokes filter.

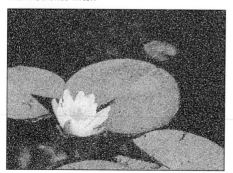

Pointillize feature.

Craquelure filter.

35. FILTERS: FOR SPECIAL EFFECTS

While the artistic filters can be used successfully on just about any image, the more dramatic ones usually need to be applied more selectively—or the effects they produce will just look arbitrary (and maybe even confusing). To apply filters, go to the Filter menu and choose from the pull-down list.

Original image.

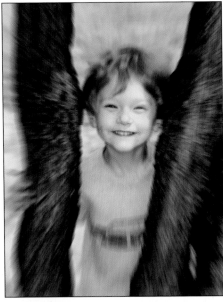

Radial Blur filter.

Original image.

Glowing Edges filter.

Original image.

Torn Edges filter.

Original image.

Spherize filter.

Original image.

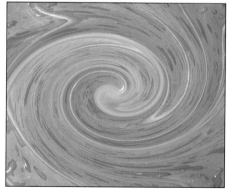

Twirl filter.

36. STRETCHING AND WARPING

There's no reason you have to keep the proportions of your subject or scene the way they were when you shot them. In Adobe Photoshop Elements, you can freely stretch and warp your images in a number of interesting ways.

To begin, open the image you want to distort (File>Open). Then, duplicate the background layer (Layer>Duplicate Layer). This will put your image on a separate free-floating layer of data.

Usually, you'll want to stretch your image. To make this easier, it helps to add some blank image space around your photograph. To do this, go to Image>Resize>Canvas Size. At the top of the dialog box that appears, you'll see the current size of your document. In the lower part of the same dialog box, just enter values for the height and width that are bigger than the current values. For easy viewing, you may wish to set the background color to white, using the pull-down menu at the bottom of the dialog box.

To create the final image (bottom), a close-up shot of the cat's face (top left) was stretched horizontally (top right).

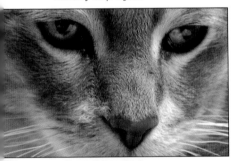
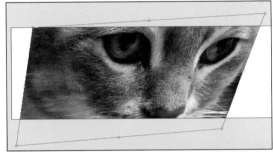

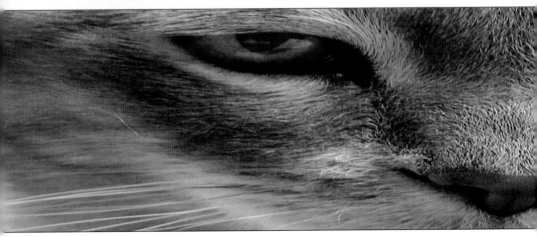

Dramatically distorting this flower image (above) created an almost abstract look (right)

The final step is to go to Image>Transform. From the menu that appears, select Free Transform. A bounding box with handles at each corner will appear over your image. Simply click and drag on these to stretch your image (see screen shot on facing page).

In the Transform menu you'll find three other choices—but they all work the same. Perspective makes things seems to advance or recede in three dimensions. Skew applies a vertical or horizontal slant to an item, while Distort stretches the item.

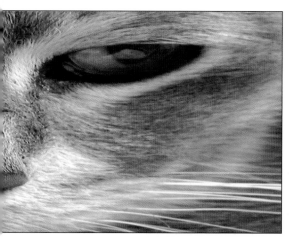

37. LIQUIFYING PHOTOS

The Liquify filter (Filter>Distort>Liquify) allows you to freely twist, stretch, and warp an image. This tool is often used to eliminate little figure flaws in portraits for a more flattering look. In advertising photography, it is even used to make a model's eyes or lips look a little bigger or more full.

To use this filter, go to Filter>Distort>Liquify. Doing so will open a full-screen dialog box with a large preview of your image in the center and two control panels on either side. To the left of your image are the tools, and to the right are the options.

To begin, select the Warp, Turbulence, Twist, Pucker, Bloat, Shift Pixels, or Reflection tool. Then, choose a brush from the Options bar. For the most impact, select a rather large brush (perhaps in the 50–100 range), and set the brush pressure to about 50.

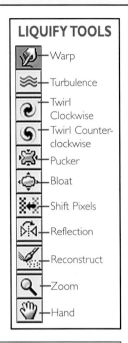

LIQUIFY TOOLS

- Warp
- Turbulence
- Twirl Clockwise
- Twirl Counter-clockwise
- Pucker
- Bloat
- Shift Pixels
- Reflection
- Reconstruct
- Zoom
- Hand

Original image.

Liquified image.

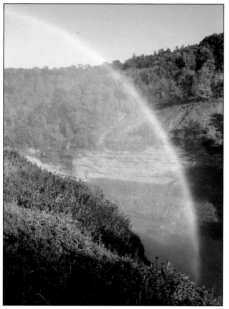

Original image.

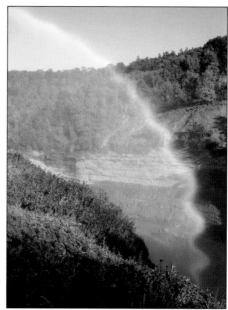

Liquified image.

Then, by clicking and dragging over the image preview, simply begin painting on the distortion. The longer you leave your brush in one area, the more the pixels there will be distorted. Try experimenting with several of the tools, using different brush sizes and

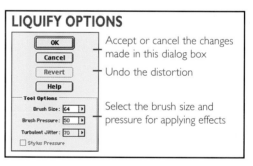

pressures, and painting quickly versus slowly. If you like the results shown in the preview window, hit OK to accept the changes. If you don't like them but you want to try again, hit Revert.

38. COMPOSITING PHOTOS

Originally, one of the most interesting uses for digital imaging was to combine elements of two images in a realistic way. While it's no longer a *primary* reason to use digital, compositing is still a great way to create other-worldly special effects.

For realistic results, the direction and quality of lighting should be very similar in both photos—an image taken with bright sunlight coming from the left won't look realistic when combined with a shot taken under soft light from the right, for example. It also helps if all of the elements are well exposed and have no big color problems. You should also check to make sure the focus is correct; a softly focused subject on a sharply focused background won't look realistic.

Look at the images carefully and decide which contains more of the material you want in the final image. In this case, the train tracks will be the background. The only part of the other image that will be used is the biker.

Therefore, the biker was selected using the Lasso and Magic Wand tools, isolating him from the background. The selection was then feathered two pix-

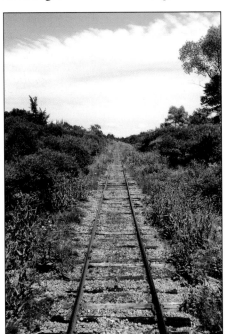
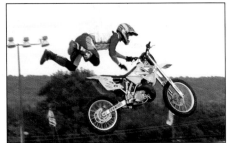

This project began with two images—one of train tracks and one of a biker doing an aerial trick (left and top right). The first step in combining the shots was to remove the background from the biker shot (bottom right).

els (Select>Feather) to soften the edges and make them less obvious when moving the subject into the train-tracks image. The selected area was copied (Edit>Copy) and pasted (Edit>Paste) into a new layer in the background image.

Correct positioning of the new element on the new layer was the next task. To do this accurately, look at the scale of the imported material. Does it need to be changed in order to make sense with the subjects around it? If so, go to Image>Transform and make any needed adjustments (see lesson 36 for more on this).

Next, look at the color and brightness of the new element in relation to the background image. Correct any prob-

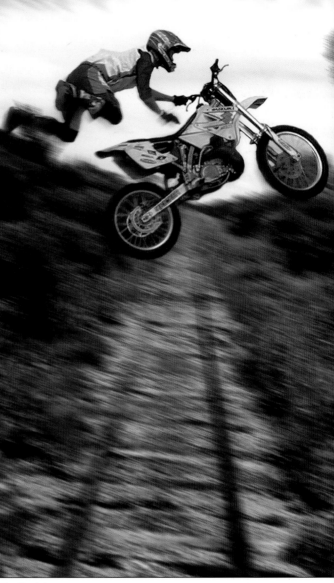

The final image.

lems by going to Enhance>Adjust Lighting or Enhance>Adjust Color.

For this image, the final step was to add some motion blur, creating the impression that the camera panned with the biker as he made this impressive leap. To do this, the image was flattened (Layer>Flatten Image) and the background layer was duplicated (Layer>Duplicate Layer). The Motion Blur filter (Filter>Blur>Motion Blur) was applied on the duplicated layer. Then the Eraser tool was used to restore sharpness as needed (on the bike and biker).

39. SCANNER ART

You may not realize it, but if you have a flatbed scanner sitting on your desk, you have a second, very specialized digital camera of sorts at your disposal. Although it is designed to "photograph" two-dimensional subjects, your scanner can be used to create interesting pictures of three-dimensional objects as well.

■ MONTAGES

Using your scanner, it's easy to create some interesting montages, as seen on the facing page. Group a few objects, photos, newspaper clippings, or other subjects on the scanner glass and make the scan using your usual scanner software. *Note:* Be sure not to place anything on the scanner glass that could scratch or nick it!

■ ABSTRACT IMAGES

One of the most interesting ways to use your scanner to create images is to employ a moving subject, as shown below. Simply set up the scanner as you would to scan a print, but leave the lid open. Then, move your subject across the glass, following the light, to get some crazy effects.

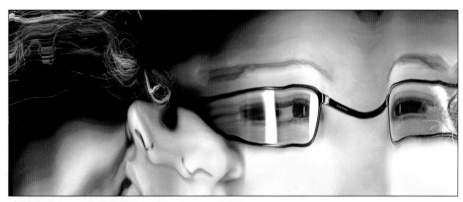

40. OUTPUT: HOME PRINTING

Purchasing a printer for your digital images can take a bit of research—there are lots of models on the market and lots of factors to consider.

■ COST

First, you'll need to consider cost—but don't look at just the cost of the print-er itself. It's extremely important to check the prices, longevity, and availabil-ity of the ink cartridges. Believe it or not, these can quickly exceed the cost of the printer itself.

■ HOW WILL YOU USE IT?

You'll also want to consider how you plan to use the printer. Will you be print-ing photos only, or do you also need to print word-processing documents and other office materials? Photo printers provide the best results for digital images, but they can be slow (and rather expensive per page) for printing other documents.

■ PRINT QUALITY

Print quality is also an important considera-tion—but don't rely strictly on resolution rat-ings. For example, an inkjet printer with a 1400dpi resolution actually won't produce as

Inkjet printers are a popular choice for printing photos at home.

good a print as a dye-sublimation printer with a 300dpi resolution. Why? As you'll read below, it has to do with the way each type of printer applies color to a page.

■ INKJET VS. DYE SUBLIMATION

When purchasing a home printer, most people will be choosing from two basic types: inkjet and dye sublimation.

Inkjet printers squirt fine droplets of liquid ink onto the surface of the paper. These models tend to be inexpensive and, for most images, do a good job of producing photorealistic prints.

With inkjet printers, consider carefully the number of inks used to print images and how the ink tanks are divided up. The general rule of thumb is that the more colors of ink you have, the better your prints will look. The mini-

mum number you will find is four (black, cyan, magenta, and yellow), but many models feature two additional colors (a light cyan and a light magenta) that enhance color reproduction. It's also advisable to purchase a model that allows you to replace each ink color individually as they run out; this will save you money in the long run.

Keep in mind that inkjet prints don't offer the same archival qualities as traditional photographs—they will fade over time (many in as little as a year or two). They can also be damaged very easily by any moisture.

Dye-sublimation printers are more expensive to purchase and to operate than inkjets, but they produce prints that look and feel much more like traditional photographs.

Dye-sublimation printers use solid inks on transfer rolls or ribbons. Rather than squirting drops of liquid ink, the solid ink is rapidly heated until it becomes a gas (a process knows as sublimation, hence the name). This allows the colors to diffuse onto the surface of the paper and provides better blending for more continuous tones. As a result of this process, the prints look smoother and have sharper detail than inkjet prints.

In addition, prints produced by dye-sublimation printers are more resistant to fading, so they last longer.

OTHER PRINTING-RELATED CONCERNS

For print longevity, your best bet is professional printing. If you must print your own images, though, look for a printer that permits the use of archival inks and papers. These are more expensive, but they offer the best chance for creating a long-lived print. Of course, inkjet technology simply hasn't been around all that long, so how even "archival" prints will actually hold up under non-laboratory conditions remains to be seen. Keeping prints cool, dry, and out of direct sunlight will certainly improve longevity, though.

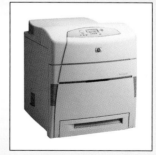

If high volume is an issue—say, you publish an illustrated monthly newsletter for the five hundred brave folks in your skydiving club—a color laser printer (right) offers nice print quality for both text and images. These printers provide rapid printing and low per-page costs.

41. OUTPUT: LAB PRINTING

For some images, an inkjet print is just fine—especially when you just want a cute new photo to stick on the refrigerator or on the front of a greeting card. Other images, however, require more permanence and the best-possible quality. You wouldn't, for instance, want the prints in your daughter's baby book to fade before she's even out of nursery school.

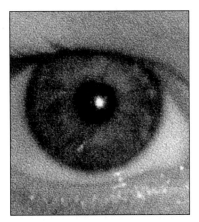

Inkjet prints are made up of tiny dots. This is revealed when the image is enlarged. Compare the detail in the eyelashes in the inkjet print (top) and the lab print (bottom).

■ REAL PHOTOS

Many people don't know they can get prints made from their digital files on the same paper and equipment used to make prints of their film images. So why make the trip to the lab? There are a lot of reasons.

True photographic prints are created using photosensitive paper and a series of chemicals, rather than inks sprayed onto regular paper. This means that the tones in the image are continuous, not made up of tiny dots. As a result, the prints look crisp and details tend to be much more sharp.

The papers and processes used to create true photographic prints are time tested. Your images will still be around for your kids and grandkids to enjoy—especially if you keep them dry and out of direct sunlight.

Let's face it, printing your own images is time consuming—especially if you want multiple sets in multiple sizes. The prints from a lab can be made in a variety of standard sizes and can be produced with matte or shiny surfaces, depending on your personal preferences.

Best of all, in addition to lasting longer and looking better, lab prints are cheaper than prints you make yourself. Most photo labs will make a 4"x6" print from your digital file for somewhere in the neighborhood of fifteen to twenty cents.

■ WHERE TO PRINT

Many drugstores, grocery stores, and department-store mini-labs now have the ability to make true photographic prints from your digital files. Just take in your memory card or CD and select the images and print sizes you want. In about an hour, your prints will be waiting for you.

The same goes for your neighborhood camera shop; take in your disc and pick out your prints. You can expect to pay slightly more here, but you'll also have the benefit of a more experienced staff that knows how to bring the best out of every image.

Online printing is very easy and affordable, and you'll usually receive your prints in about a week. Online labs have some other nice features as well. Most allow you to set up albums of images to share with friends. This is great for images of big events like reunions; you just upload your photos and e-mail a link to the site to your family or classmates. They can then order whatever prints they want directly from the site, so you don't have to worry about who wanted what and how to get it to them. Many online labs also offer a selection of borders and text you can add to your images, as well as an assortment of fun photo products that can be ordered right along with your prints. Some even have professional image retouchers available who can tackle tricky jobs you aren't prepared to do yourself.

Best of all, most online photo labs will let you try out their service for free. Typically, they provide about ten free prints when you set up a new account. You'll need to spend a couple of dollars on shipping, but you'll get a good sense for how the site works and the quality of their images.

ONLINE PHOTO LABS

www.agfa.com	www.hpphoto.com	www.smugmug.com
www.aol.com	www.mpix.com	www.snapfish.com
www.bonusprint.com	www.ophoto.com	www.togophoto.com
www.clarkcolor.com	www.photoaccess.com	www.walmart.com
www.clubphoto.com	www.photoworks.com	www.winkflash.com
www.dotphoto.com	www.printroom.com	www.xpphoto.com
www.ezprints.com	www.ritzcamera.com	www.yahoo.com
www.fujifilm.net	www.shutterfly.com	www.yorkphoto.com

CLOSING THOUGHTS

Special effects photography used to be a real challenge—and coordinating all the facets of some of the more complicated shots can still take some trial and error, to be sure. As a whole, however, digital has made it easier than ever for even beginning photographers to create the dramatic images that even a few years ago were the exclusive provenance of trained professionals.

As you try out some of the ideas in this book, don't be afraid to combine them, adapt them, or totally revamp them as you like to suit your subject or creative vision. Keep your eyes open for other images with special effects and try to figure out how the photographers accomplished them—then try out the techniques on your own. With a little practice and creativity, you'll find your images getting better and more interesting.

Most of all, have fun. With instant feedback on your LCD screen and the ease of sharing images on-line with friends and family around the world, there's never been an easier or more exciting time to take up photography. And with no film or developing costs, there's no reason not to indulge your every creative whim.

Good luck and happy shooting!

GLOSSARY

Aperture—The opening in the lens that light passes through to make an image. If it's wide, the scene will fall out of focus as objects recede from the point on which you are focused. If it's narrow, more of the scene will be in sharp focus.

Archival Quality—The ability of a medium to resist deterioration. The term is often used to describe prints that resist fading and color changes.

Auto Mode—On digital cameras, a setting where the camera makes all the decisions about exposure, focus, flash, white balance, etc. This mode is good for fast shooting under changing conditions and for inexperienced camera users.

Burst Rate—The number of images a camera can shoot in rapid sequence before it needs to pause and process the files. High burst rates are good for photographers who like to shoot fast-action subjects like sports.

Card Reader—A device used to transfer data from memory cards without the need to connect your digital camera to your computer.

CompactFlash—A type of memory card used by many digital cameras.

Compositing—Combining parts of two or more photographs (or other types of images) to create one final image.

Composition—The art of carefully designing an image and consciously deciding how to frame a scene or subject. *See also* Rule of Thirds.

Contrast—The difference between the lightest and darkest tones that appear in the image.

Cropping—Removing extraneous areas from the edges of a photograph.

Dye-Sublimation Printer—A type of printer in which dry colorants are rapidly heated to a gas state then transferred to and solidified onto paper.

Filter, Digital—Used within image-editing software to apply a specialized effect to an image.

Filter, Photographic—Transparent material that attaches to the lens of a camera and allows you to adjust the light entering the camera in creative ways.

Focusing, Close—A setting on many digital cameras that allows you to bring your lens to within a few inches of your subject and still get a well-focused shot.

Highlights—The lightest areas in your image.

Highlights, "Blown Out"—Highlight areas that are so overexposed that they lack any detail.

Image Modes—On digital cameras, preset shooting options designed to produce good results with a particular kind of subject (landscapes, portraits, etc.).

Image Sensor—With digital, the part of the camera that captures the image. Its unique qualities determine the resolution of the images captured on it.

Image Stitching—*See* Panoramic Images.

Inkjet Printer—A type of printer in which tiny drops of ink are squirted onto paper (or a different type of media).

Interpolation—The process of inserting extra pixels into a digital image to increase its size or resolution.

ISO Setting—On a digital camera, how sensitive to light the image sensor is set to be. Higher ISO settings allow you to work more easily in low light but produce more noise, which can reduce the image quality.

Landscape Mode—A shooting mode in which the camera will select the smallest practical aperture in order to keep as much as possible of the scene in focus.

LCD Screen—A screen on the back of a digital camera that is used to access menus, compose images, and review photographs.

Light Meter—An instrument built into digital cameras that measures the light reflected off a subject and recommends an appropriate exposure setting.

Macro Setting—*See* Focusing, Close.

Manual Mode—On digital cameras, a setting where the photographer makes all the decisions about exposure, focus, flash, white balance, etc.

Metering—Evaluating the amount of light in a scene to determine the correct exposure.

Midtones—All of the tones in an image that are neither pure white nor pure black.

Night Portrait Mode—An image mode that allows you to balance a dark background with a flash-lit foreground subject.

Noise—A grainy appearance in digital images that occurs when using high ISO settings or may be added intentionally using image-editing software to create a desired look.

Panoramic Images—Long, narrow photographs that show as much as a 360-degree view of a scene. Many digital cameras now offer a mode that helps

you shoot a sequence of images you can later combine into a single panoramic shot. This is often referred to as "image stitching."

Plug-ins—Plug-ins are small programs that run from within a major application like Adobe Photoshop or Adobe Photoshop Elements. Because of the prominence of Photoshop, most plug-ins are written in a Photoshop-compatible format. You don't have to use Photoshop, though; many other imaging applications (including Photoshop Elements) accept Photoshop-compatible plug-ins.

Portrait Mode—A shooting mode in which the camera will select the widest practical aperture in order to allow the area behind your subject to go quickly out of focus, making it visually less distracting.

Program Mode—The program mode (usually indicated by a "P") allows you to control some settings (like white balance, ISO, etc.) but not as many as the fully manual mode.

PSD—A file format used by Abode Photoshop Elements to save images without flattening any layers that are included.

Red-Eye Reduction—Red-eye occurs when the lens and light source are directly in line with the subject's eyes. There are two ways to combat this effect. (1) Most cameras now include a red-eye reduction setting. When this setting is used, an initial burst of light closes down the pupil, preventing the second burst of light from reflecting off the retina and back into the camera (which is what makes the center of the eye look red). (2) If red-eye still occurs, you can fix it easily in your image-editing software.

Retouching—Using image-editing software to reduce or correct problems in an image that were unnoticed or impossible to correct at the time the image was taken.

RGB—The color mode in which scanners, digital cameras, and monitors—devices that receive or transmit light—all capture or display color.

Rotate—To turn a selected area of image data (or the entire image) around a fixed point.

Save—To preserve an image for future use (including further editing, viewing, and/or use in another application).

Scanner, Flatbed—Device used to digitize photographic prints and other flat, reflective surfaces.

Shadows—The darkest areas in your image.

Sharpen—To increase the apparent focus of an image (or area of an image) to enhance the clear reproduction of image detail.

Shutter Priority Mode—In this mode (commonly indicated by "Tv"), you select the shutter speed and the camera selects the best aperture setting to match the brightness of the scene. Choose a short shutter speed to freeze moving subjects, or a long one to blur them.

Shutter Speed—How long the camera's shutter remains open to make an exposure. When you (or your camera) choose a long shutter speed, subjects in motion will be blurred in your image; when you choose a short shutter speed, subjects in motion with be frozen in your image.

Timer—Like most point-and-shoot film cameras, your digital model will probably have a timer that allows you to set the camera and then duck into the shot.

Viewfinder—With digital cameras, a window (like on a traditional film camera) that can be used to compose images with the camera held up to your eye.

White-Balance Settings—Settings designed to balance the colors in a scene for accuracy under just about any kind of light—sunlight, fluorescent light, tungsten light, etc.

Zoom, Digital—On a digital camera, this is image enlargement that is provided by software rather than the lens. This reduces the image quality and should usually be avoided. *See also* Lens, Zoom *and* Zoom, Ooptical.

Zoom, Optical—On a digital camera, this is image enlargement that is provided by the mechanical qualities of the lens. This produces sharp images. *See also* Lens, Zoom *and* Zoom, Digital.

INDEX

OTHER BOOKS FROM
Amherst Media®

BEGINNER'S GUIDE TO
ADOBE® PHOTOSHOP® ELEMENTS®
Michelle Perkins

This easy-to-follow book is the perfect introduction to one of the most popular image-editing programs on the market. Short, two-page lessons make it quick and easy to improve virtually every aspect of your images. You'll learn to: correct color and exposure; add beautiful artistic effects; remove common distractions like red-eye and blemishes; combine images for creative effects; and much more. $29.95 list, 8½x11, 128p, 300 color images, index, order no. 1790.

DIGITAL LANDSCAPE PHOTOGRAPHY
STEP BY STEP
Michelle Perkins

Learn how to capture the drama and majesty of nature. Using a digital camera makes it fun to learn landscape photography—and provides instant results so you can instantly learn from each successful shot you take. Short, easy lessons ensure rapid learning! $17.95 list, 9x9, 112p, 120 color images, index, order no. 1800.

THE PRACTICAL GUIDE TO DIGITAL IMAGING
Michelle Perkins

This book takes the mystery (and intimidation!) out of digital imaging. Short, simple lessons make it easy to master all the terms and techniques. Includes: making smart choices when selecting a digital camera; techniques for shooting digital photographs; step-by-step instructions for refining your images; and creative ideas for outputting your digital photos. Techniques are also included for digitizing film images, refining (or restoring) them, and making great prints. $29.95 list, 8½x11, 128p, 150 color images, index, order no. 1799.

PROFESSIONAL TECHNIQUES FOR
BLACK & WHITE DIGITAL PHOTOGRAPHY
Patrick Rice

Black & white photography is an enduring favorite among photographers—and digital imaging now makes it easier than ever to create this classic look. From shooting techniques to refining your images in the new digital darkroom, this book is packed with step-by-step techniques (including tips for black & white digital infrared photography) that will help you achieve dazzling results! $29.95 list, 8½x11, 128p, 100 color photos, index, order no. 1798.

BEGINNER'S GUIDE TO PHOTOGRAPHIC LIGHTING

Don Marr

Learn how to create high-impact photographs of any subject (portraits, still lifes, architectural images, and more) with Marr's simple techniques. From edgy and dynamic to subdued and natural, this book will show you how to get the myriad effects you're after—and you won't need a lot of complicated equipment to create professional-looking results! $29.95 list, 8½x11, 128p, 150 color photos, index, order no. 1785.

STEP-BY-STEP DIGITAL PHOTOGRAPHY, 2nd Ed.

Jack and Sue Drafahl

Avoiding the complexity and jargon of most manuals, this book will quickly get you started using your digital camera to create memorable photos. $14.95 list, 9x6, 112p, 185 color photos, index, order no. 1763.

OUTDOOR AND LOCATION PORTRAIT PHOTOGRAPHY, 2nd Ed.

Jeff Smith

With its ever-changing light conditions, outdoor portrait photography can be challenging—but it can also be incredibly beautiful. Learn to work with natural light, select locations, and make all of your subjects look their very best. This book is packed with illustrations and step-by-step discussions to help you achieve professional results! $29.95 list, 8½x11, 128p, 80 color photos, index, order no. 1632.